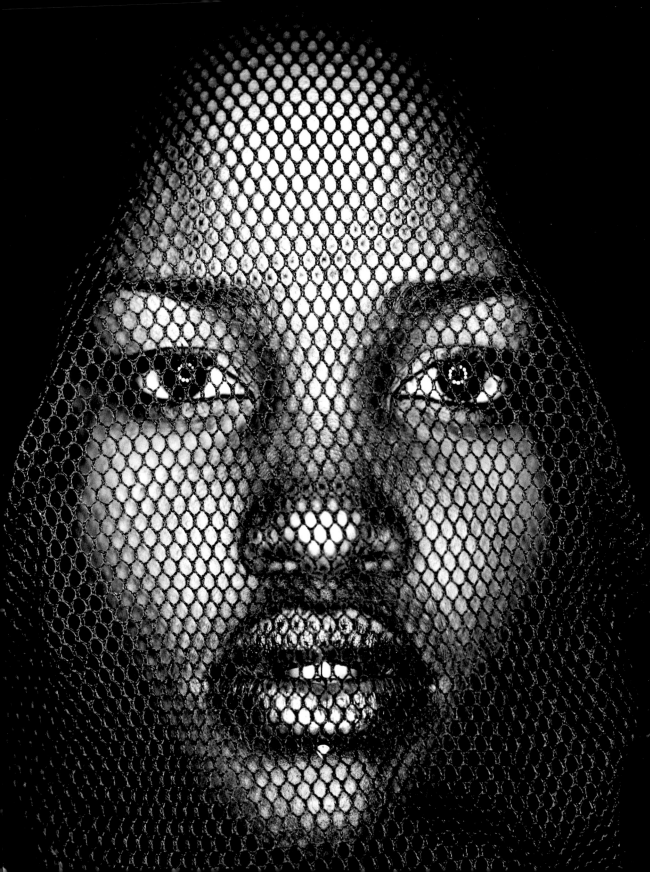

OVERLEAF:

LUPITA NYONG'O

DARK GIRLS

BILL DUKE'S
DARK

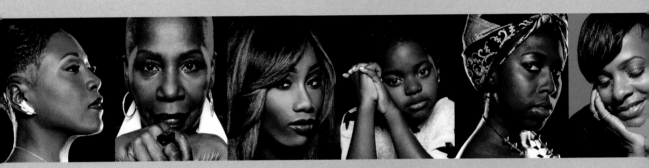

Amistad

An Imprint of HarperCollinsPublishers

GIRLS

INTERVIEWS BY SHELIA P. MOSES

PHOTOGRAPHS BY BARRON CLAIBORNE

HarperCollins books may be purchased for educational,
business, or sales promotional use. For information, please e-mail
the Special Markets Department at SPsales@harpercollins.com.

FIRST EDITION

Designed by Suet Yee Chong
On the exterior of the case: Lupita Nyong'o

Library of Congress Cataloging-in-Publication Data has been
applied for.

ISBN: 978-0-06-233168-7

14 15 16 17 18 OV/QGT 10 9 8 7 6 5 4 3 2 1

I DEDICATE THIS BOOK TO

MY MOTHER, ETHEL DUKE,
MY SISTER, YVONNE DUKE HAMPTON,
HER DAUGHTER, NALO,

AND

TO DARK GIRLS EVERYWHERE.

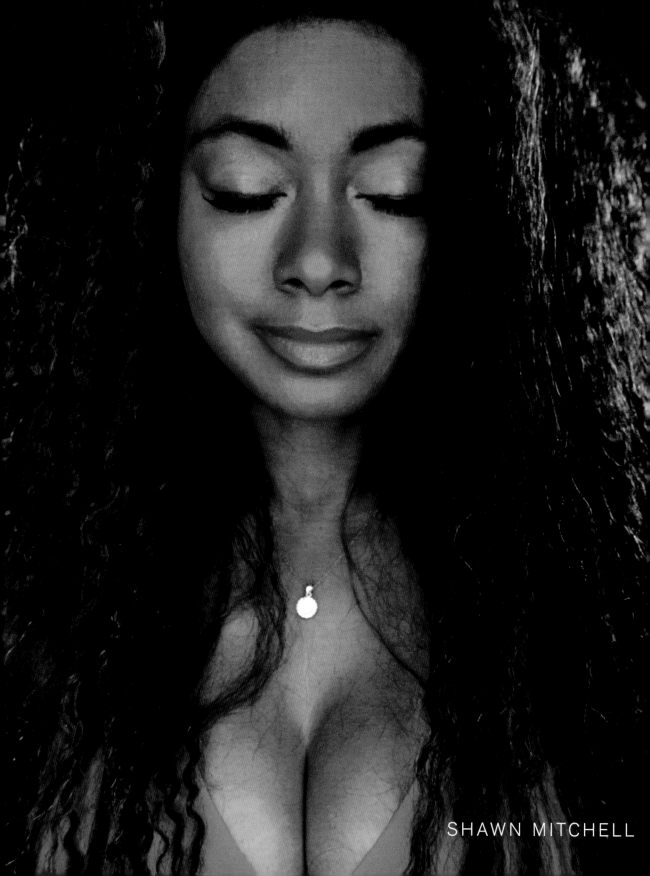

"Sometimes I forget I'm a dark girl because I have so many other wonderful things going for me."
—LORETTA DEVINE

WORDS FROM
BILL DUKE

I came into this world from the warm body of a dark girl. A very dark girl. She is the one I loved most in this world, my dear mother, Ethel Duke. Her husband and my beloved father, William Duke, Sr., was also dark—dark and proud. Every day of my life I think about my parents, who have gone on to glory. I think about their struggles. I think about our struggle as a family. I think about our darkness.

I grew up in upstate New York in the small town of Poughkeepsie. Our darkness was not welcomed. As a child, I lived with my only sibling, Yvonne, in the comfort of my parents' home and felt loved by them and our extended family. We ate, laughed, and served God together. They made me feel safe.

When I left my parents' home, people were not kind to me because of the color of my skin. The world showed me hatred

not only because I was a black boy, but because I was not light skinned.

I was excited like any first grader would be when I put on my new clothes for the first day of school. Clothes that I am sure my parents spent their last dime to buy for me. I was a normal, happy little boy. I did not know that it mattered that the teacher and most of the students were white.

"Stand up and shake each other's hands," the teacher instructed the students. Not one person touched my black hands. Not one! Then she asked us to stand and state our names. When it was my turn, I stood, but I could not speak. The fact that no one touched my *dark* hands had silenced me.

"What is your name?" she asked.

"Duke," I managed to say.

"Duke. Is Duke your first name or your last name, young man?"

"No, it is Bill Duke."

Laughter rang across the classroom. On the ceiling. On the walls. My darkness was not welcomed. I sat back down and my normal little world changed. It has never really been the same since then. When you realize others will harm you just because you are not their skin color, life starts to look different.

When my teacher gathered us for lunch, I sat alone. The little white boys were ready to finish the job they had started in the classroom.

"'What's your name?'" one boy asked another boy, as if I were invisible.

"'My name is Duke,'" his friend said.

"'Is that your first name or your last name?'"

"'That's my last name,'" the boy answered as they all laughed.

"Oh, I thought it was n—," another boy laughed.

"No. My name is black n—," one boy said.

I don't remember anything else after that. When I was aware of my surroundings again, I was running into the house past my parents. I went into the bathroom, removed all of my new clothes, threw them on the floor, and ran bathwater. I wanted to wash the pain away. I wanted to wash my darkness away. The proud little black boy I used to be was gone.

After my bath I was still "black n—" like the white boys called me at school. I remembered how my mother used bleach to make towels and other linens white, so I thought it would turn me white, too. As I put the jug to my lips my mother stopped me.

"They called me a n—, Mama," I whined.

As she removed the bleach that would have killed me from near my lips, she began to cry. She knew. She knew my blackness was not welcomed. My little sister ran in and started crying, too. My father did not cry. His face was like stone. He knew that my struggle as a black man had begun. He knew that I was about to walk down the same road he had traveled. He knew I was no longer just his son; I was a n— to my white friends. He was hurt to the core of his soul.

That was the day my parents became even more protective of me and my sister. I went back to school the next day holding my sister's hand, trying to protect her from what would become a lifetime of pain for both of us. My dad went off to work angry, and my mom tucked her heart back into her body and went off to the Dutchess County mental ward, where she worked for thirty years. She worked with the brokenhearted and the unwanted. She

knew pain, like her patients' pain, had come home to her children.

My momma and daddy continued to give us all the love they had. They tried so hard to show us a better world. There were times when they had little to no money to do things for us, not even enough money to go to the movie theater. On Saturday nights we would walk to the local theater and sit down on the sidewalk. That was where my life as a filmmaker really began.

"What do you think that man does for a living?" my father would ask, as a man walked past us.

With Yvonne's help, I would just make up a story about the person to tell our parents.

"What about him?" my mother would ask.

We would do this for hours. Just the four of us, as a family. We had no money to go inside—besides, our darkness was not welcomed. For years to come we remained close and protected each other with love. My mother and father are gone now, and I have my dark girl sister left to love and to be loved by. I have her daughter, Nalo, who is also a dark girl.

This book is for my mother, but it is also for Yvonne and Nalo and all the dark girls around the world. My mother inspired me to direct the documentary *Dark Girls*. The talks I had with Yvonne and Nalo about their journey as dark girls also inspired me. Watching them be ignored by men because of their darkness made me determined to tell their story one day. When I started the research, I did not have to go to the library or a bookstore. I had lived my life with dark girls.

When I started recording their stories for the documentary, my mother's face was etched in stone with every word they spoke. I could hear her voice saying, "Tell the story, child. Tell the story."

When the documentary was aired on OWN, women from across the country reached out to me to say, "Thank you for telling our story." Like many people in the industry, Shelia P. Moses called me after the documentary and said, "You know, that should be a book."

The selection process for the women included in *Dark Girls* was tough. Many women were interested. We used the historical standard of the brown paper bag. The women in this book are darker than that bag, and unfortunately our society still gives preference to those who are lighter. Some of the beautiful women featured here are very dark, and others are just the darkest in their own families.

Dark Girls honors the women society would like to ignore, the ones darker than the paper bag. The impact that I hope this book will have is twofold: First, I hope that the pictures and words will enable young dark-skinned girls globally to see and accept their own beauty and begin to dissolve issues of low self-esteem. Second, I hope to influence the global ideology that perceives whiteness as more beautiful, acceptable, and more meaningful than darkness.

My prayer for *Dark Girls* is to help readers rethink the impact this debilitating and destructive idea has on our children in the present and will have on our children in the future.

To my dark girls: You are loved. I honor you—and yes, your gorgeous darkness is welcomed on this earth.

DARK GIRLS

TESS WANJUGA

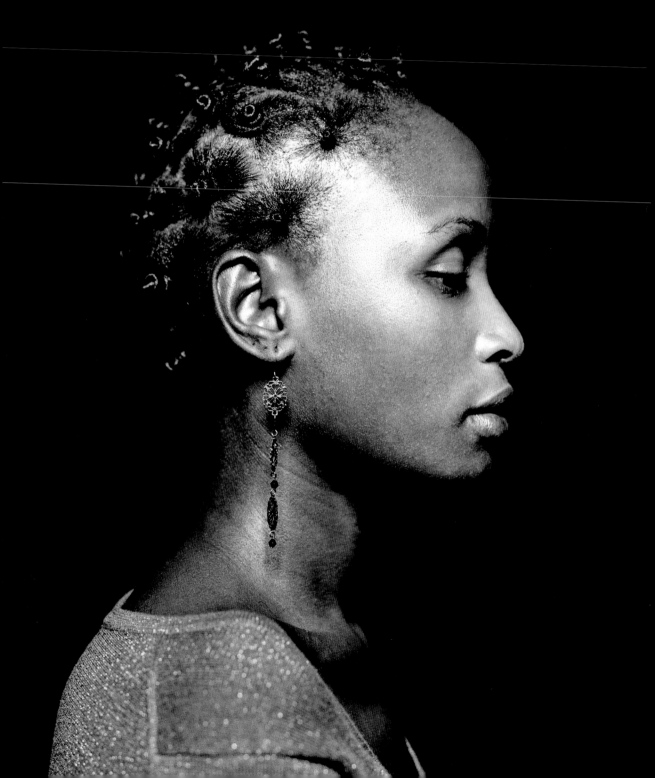

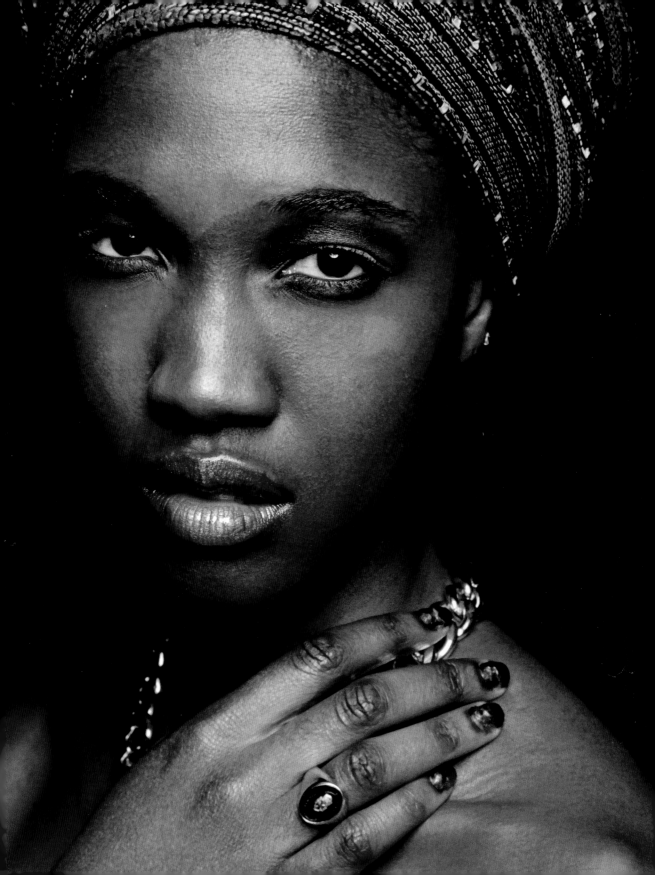

CHIIJMREE WILLIAMS

PRODUCER

Any negative views about me as a dark girl are that person's darkness. The way I view myself is my light.

I was in the fifth grade at a predominantly white private school when I realized that my skin color was not okay with the other students. When you are ten you just want friends.

I was confused when I realized my white friend could no longer play with me because her mother told her she could not play with black girls. What was even more hurtful was she told our mutual light-skinned friend not to play with me, thinking she was white! I cannot tell you how ugly that made me feel.

I carried that experience with me into high school, where the black boys treated me like the little girl in fifth grade did. The young men would ask my lighter friends out on dates but not me. They simply did not want to date the darkest girl in the class. I never told my mother how hurt I was by those boys, even when she asked me why I was upset.

Today, I know that I am not the problem. I know that I am not the ugly duckling. Men have a right to their preference, and I have the right to understand my own beauty. I love being a dark girl. My darkness shaped me into the person I am today.

SHERYL LEE RALPH

ACTRESS, SINGER, AND ACTIVIST

Being a dark girl has never bored me. It never will. I am a Haitian woman, and where I come from black is truly beautiful. My native people say it and they mean it. I am grateful for that. I was reminded of how beautiful black really is when I went home a few years ago and had an encounter with a little Haitian girl. She was walking with her mother when she spotted me on the street. She looked at me with her kind youthful eyes and said with disappointment, "Mommy she is not as dark as I thought she was." That made me so happy! Happy, because I was not dark enough for that baby. How about that?!

I was so proud at that moment. Proud that this small child was happy to be a dark girl. Confidence like that you are born with. I know that for sure because my mother and father put that same power in my soul. They told me I was beautiful all my life, as did my brothers. So that is what I will always believe.

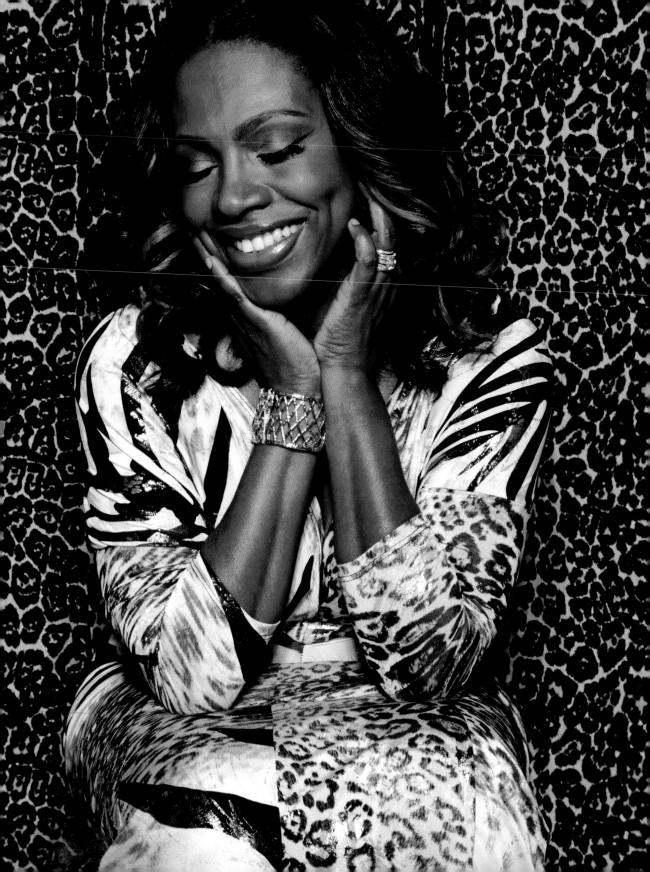

"I wanted the hair! The long silky hair that blew in the wind, that I could flip with the twitch of my neck or comb my fingers through. I was a little dark girl being bombarded with images of beauty in the media that were the polar opposite of what I was seeing in the mirror. However, the shade of my skin was not my issue; I simply wanted 'the hair.' Although I didn't know it then, I was transitioning from innocence to color-consciousness. I was a little dark girl who did not understand and accept my beauty.

"Thanks to my loving and proud parents, my wish for hair that blew in the wind was eventually blown away. Early in my undergraduate years, I went natural. I have been nappy and happy ever since!"
　　　　　　　　　　　—ROBYN GREENE ARRINGTON

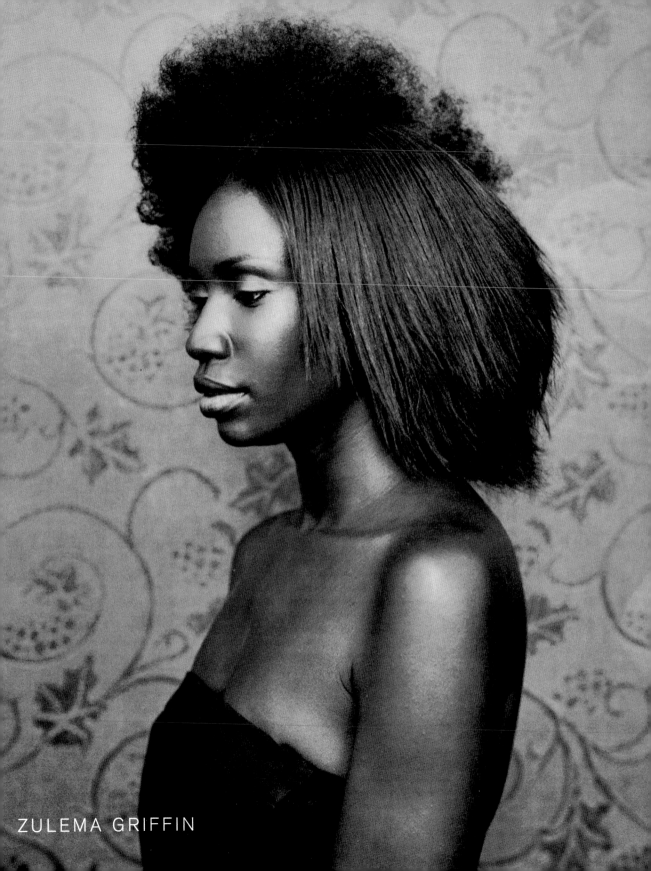

ZULEMA GRIFFIN

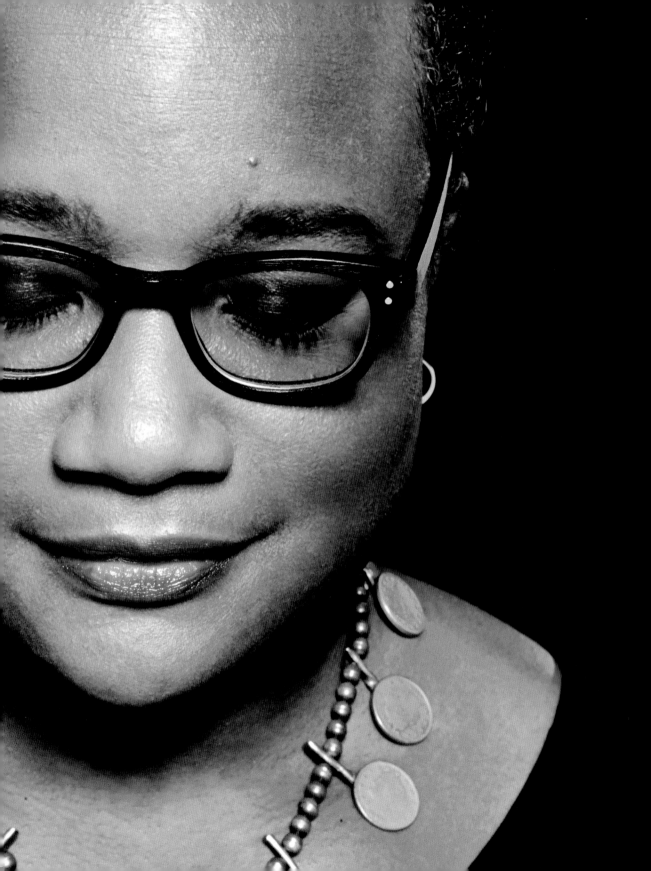

RETHA POWERS

AUTHOR

Ninety percent of beauty is between the ears. It's an inside job.

Every day on my bus a group of third grade girls told me that I sounded white. I was in kindergarten and unable to defend myself. I remember when another dark-skinned girl started riding my bus, the little girls shouted, "Darkie! Darkie!" at her mercilessly. She started to cry and I was relieved that I was not alone. A few days later they were back to me. It was like a war zone, only they were using their words as weapons to kill our spirits.

Years later in a different school the same racism came back to visit me one day when the teacher walked out the door for just a few minutes. "Where is Retha?" one of the boys in my class asked. "I can't see her. Retha, would you smile so we can find you." I was eight or nine years old and confused by the boy's mean

words as the whole class laughed. I was thinking, *I can see you, why can't you see me.* It took me a minute to truly understand what he was saying, but I knew for sure I was the darkest person in the class. Once I got it I was hurt, because I love my dark skin. I was taught by a dark mother and women of various hues to love and appreciate our darkness.

When I was ten I read *Song of Solomon*: "I am black, but comely, O ye daughters of Jerusalem." The word "but" was a stinger for me over the years; however, I understood it as an acknowledgment that there are negative views of darkness coupled with an insistence on being beautiful anyway. I looked in the mirror and said it over and over again, my negative feelings about my darkness ceased, and I realized I had to insist.

I now have a beautiful six-year-old dark girl. I doubt if she is being teased at school, but it's a possibility. The signs I see are her asking for her hair to be down and not in Afro-puffs. That is her young mind longing for the hair she sees on some of her classmates or princesses. I question her about her request. I hope this will be easier for her and that she will see her beauty and intelligence inside and out—black *and* comely.

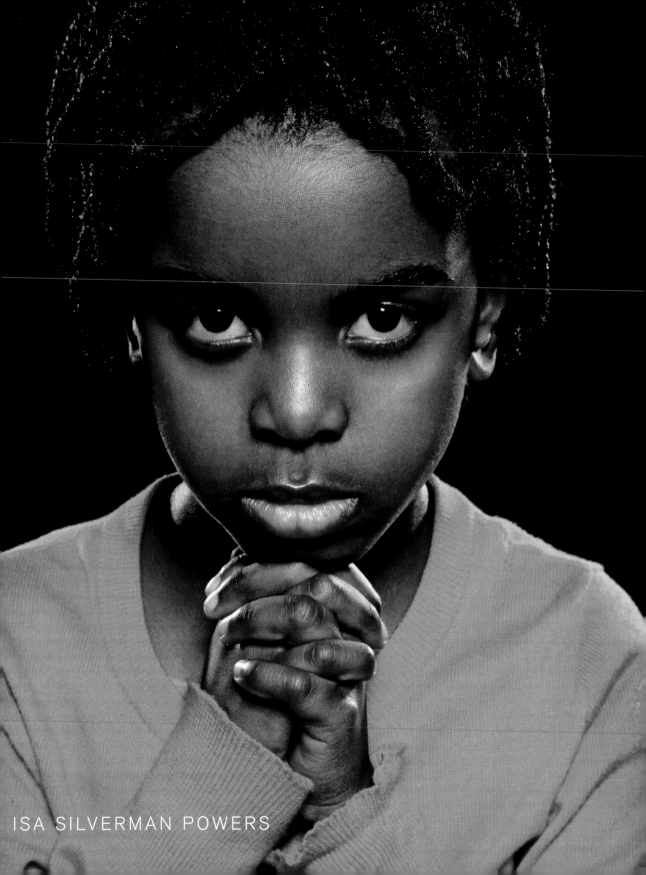

ISA SILVERMAN POWERS

DANA NICKERSON

RESPIRATORY THERAPY SUPERVISOR AND STUDENT

I survived breast cancer twice, so being a dark girl is secondary. Having breast cancer put my life into perspective in a way nothing else could have. Breast cancer is *not* a dark girl disease. It doesn't care who you are or what you look like. God has allowed me to beat cancer twice; therefore, what people say about my dark skin no longer hurts me the way it did when I was a child.

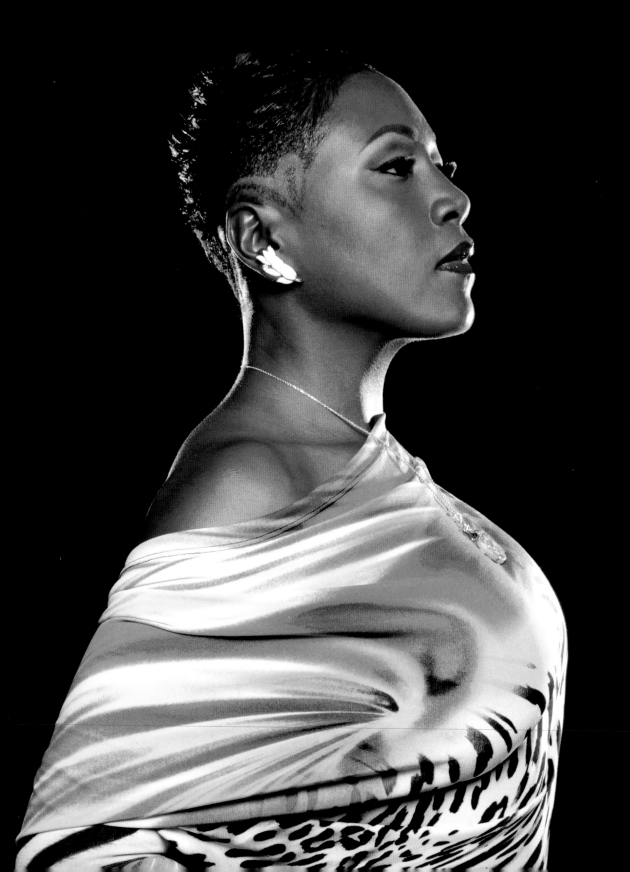

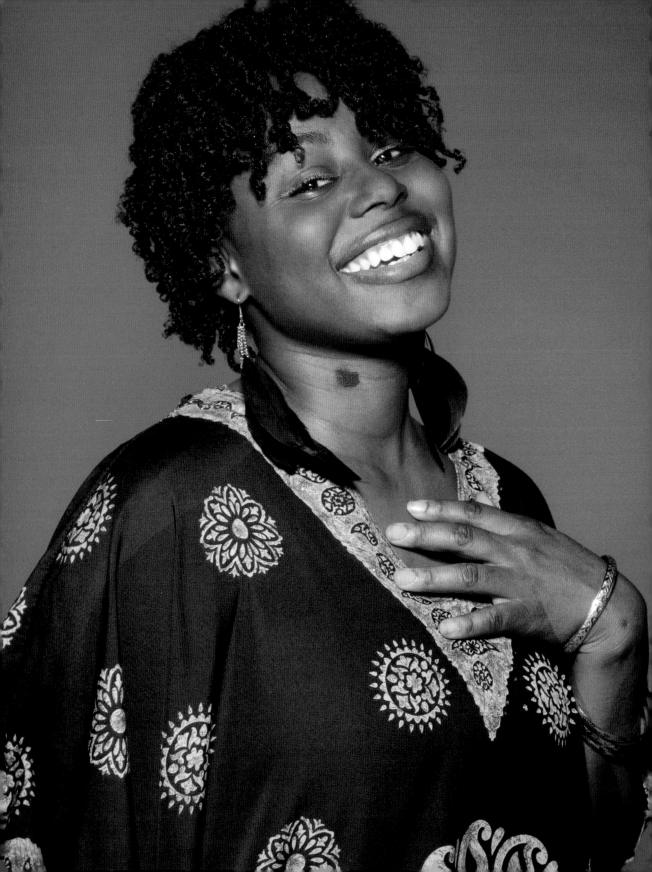

A'KIA SHE'KIBA BENBO

COLLEGE STUDENT

My mother told me all my life that I was beautiful and that is what I will always believe. That's what matters at the end of the day—how you feel about yourself and how you see yourself.

Go forth boldly, dark girls. Stay at your best.

"What other people think of this dark girl is none of my business."

—SHERYL LEE RALPH

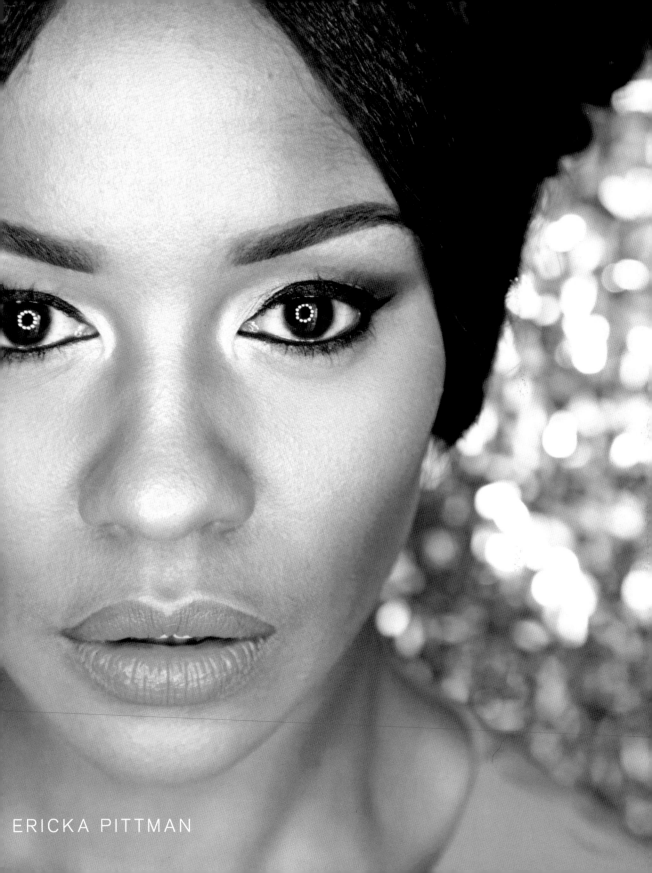

ERICKA PITTMAN

"Say it loud—I'm black and I'm proud."

—JAMES BROWN

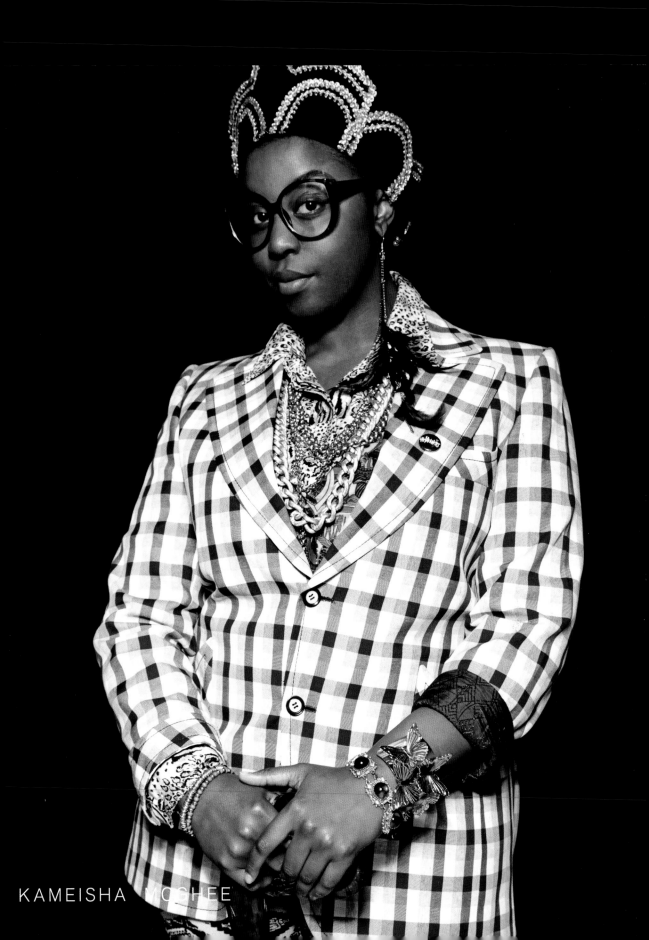

KAMEISHA MCGHEE

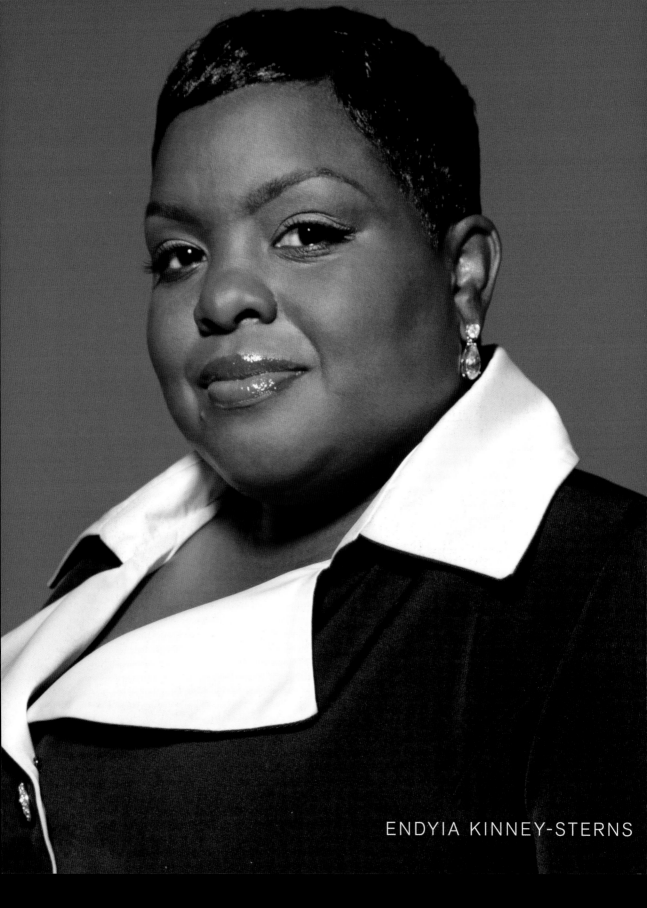

ENDYIA KINNEY-STERNS

"Dark girls, God is your king; therefore, you are all princesses. And someday you will be queens." —ENDYIA KINNEY-STERNS

YVONNE DUKE HAMPTON

JEWELRY MAKER

As I was growing up, my parents always made me feel beautiful. When the kids at school would laugh at me and make fun of the color of my skin, I would come home crying. My parents would then comfort me and say, "Don't get upset about that—God only makes beautiful things. The color of your skin is beautiful." Believing that strengthened me and allowed me to go on.

It's a great life if you don't weaken it.

CARLA B. FERRELL

RADIO HOST AND CREATOR OF LIPS BY CARLA

When it was time for me to go to college, my mother said, "Be proud to be a black woman, and attend a HBCU. Love yourself, your race, and your heritage." When I arrived at Prairie View A&M University, I found women of all colors, and I was so happy to see all of the dark girls. We bonded as women. We supported each other, studied, partied, and matured together.

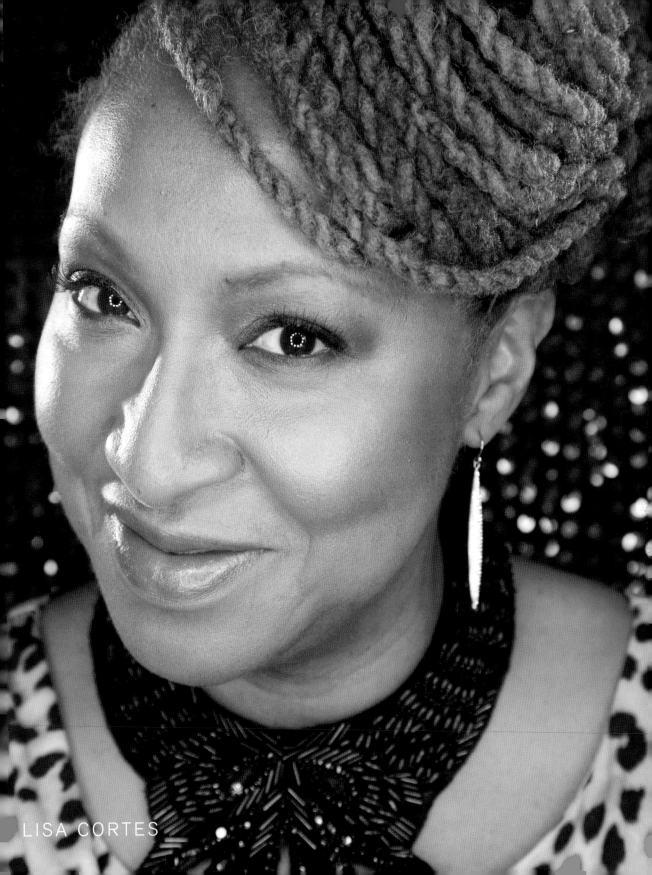

LISA CORTES

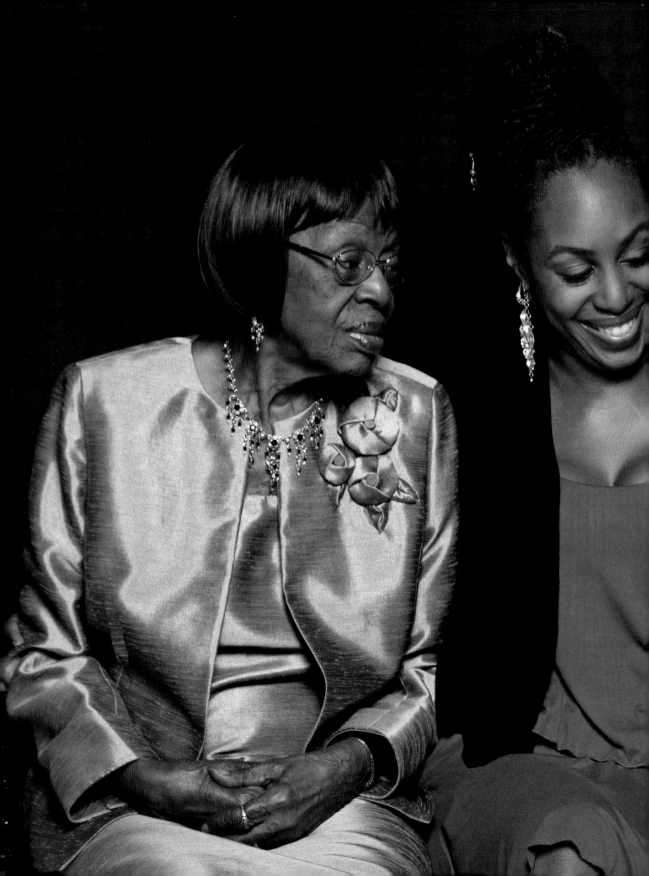

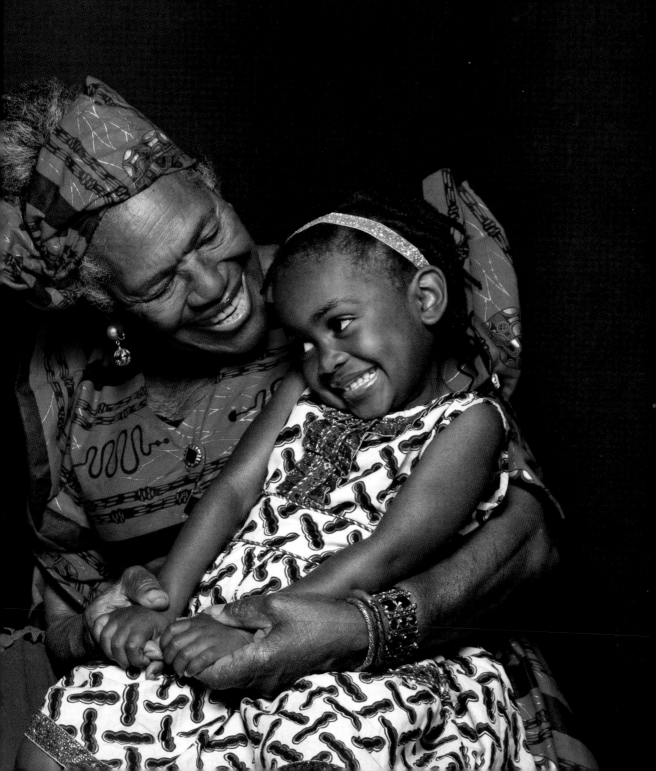

JESSICA BLAYLOCK WILLIAMS

COLLEGE STUDENT

I remember walking through an art exhibit hall with one of my friends in high school, when we saw a painting of a woman with a darker complexion. As if I were invisible she said, "I don't know what I would do if I was dark." That was the moment I realized that people have no problem saying dark is bad. People say I have beautiful skin, but they do not say I am beautiful.

I look in the mirror and I can see my roots, which hold a history as deep and rich as my skin.

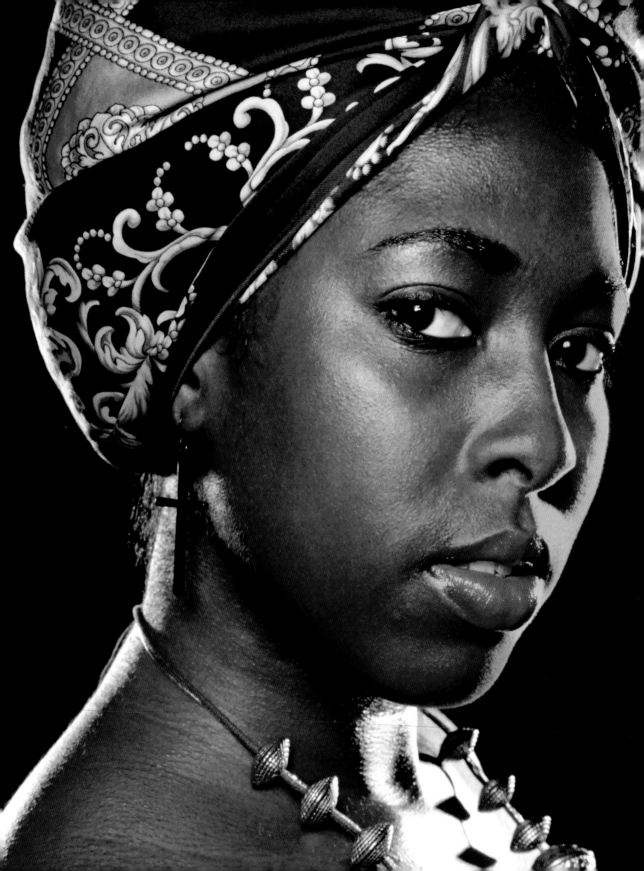

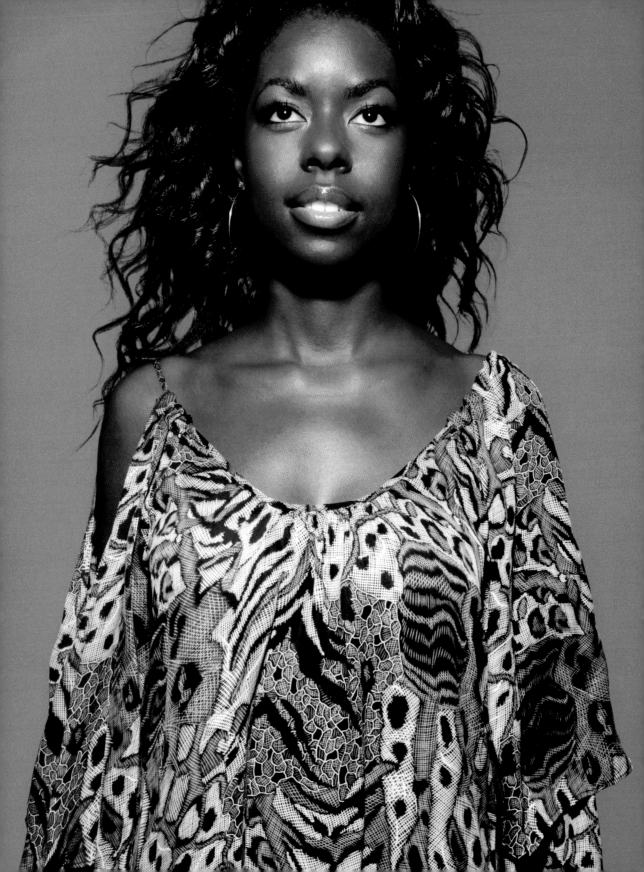

CAMILLE WINBUSH

ACTRESS

"You are so pretty to be a dark girl" is the comment I have heard all my life. Even as a child I realized that people did not understand that dark was normal and beautiful. I remember being in a fashion show and standing backstage waiting my turn, when a little white girl turned to me in dismay and said, "You do not look like us. What's wrong with you? You are so dark." I was only twelve trying to explain the best I could that there was nothing wrong with me or my skin tone. She was also twelve and had no clue that she had hurt my feelings.

MOOKIE NGENGE

STYLIST AND SINGER

HIM: "Wow, you are so pretty to be dark skinned."

ME: "Naw, I'm just pretty."

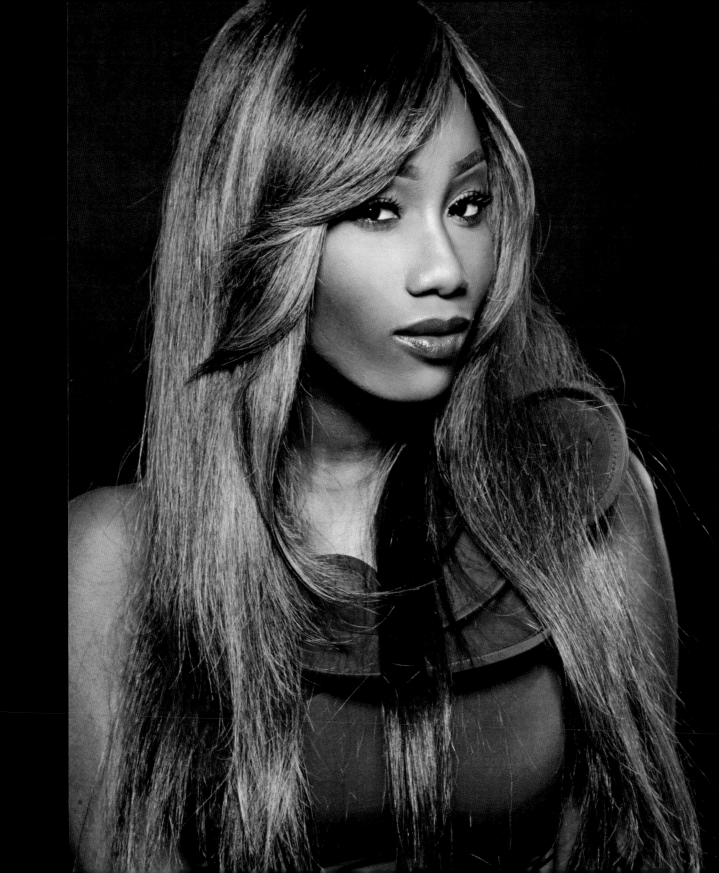

"I have never let what anyone said or believed make me stop loving the color of my skin. I'm a chocolate dream. I run to the sun, not away from it."

—MORENIKE EFUNTADE EVANS

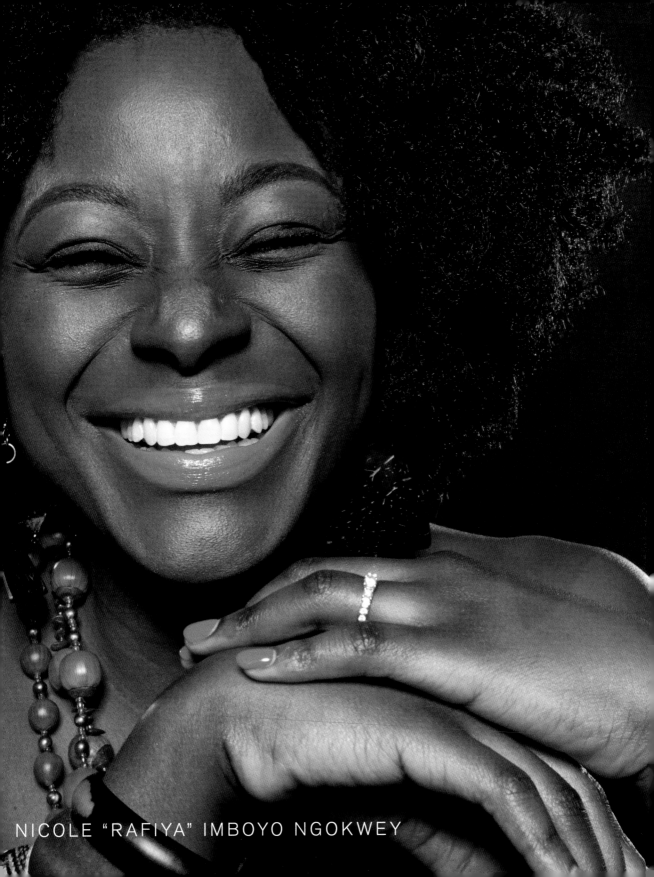

NICOLE "RAFIYA" IMBOYO NGOKWEY

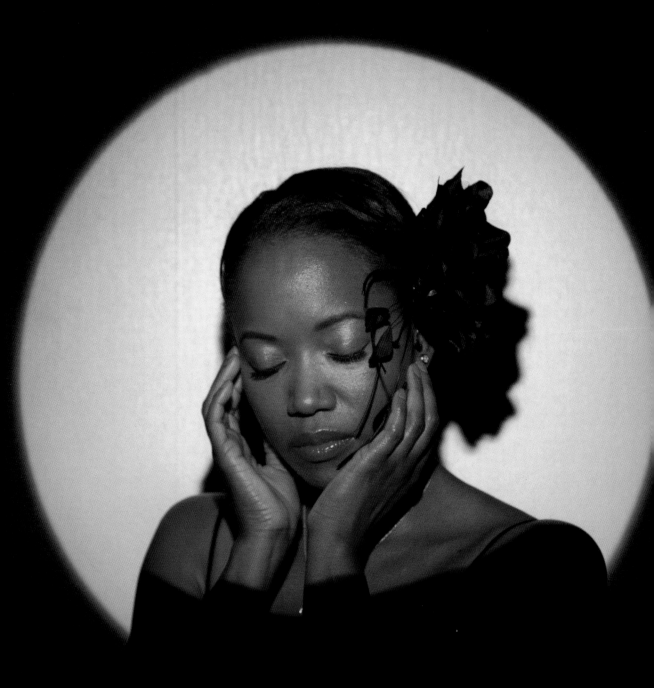

ERIKA ALEXANDER

ACTRESS

I started out very young in show business, so the lessons of a dark girl came to me quickly. I remember just like it was yesterday when my agent said to me, "No one would ever mistake you for an ingenue." She was so calm when she said it and she really meant me no harm. That was her truth, not mine.

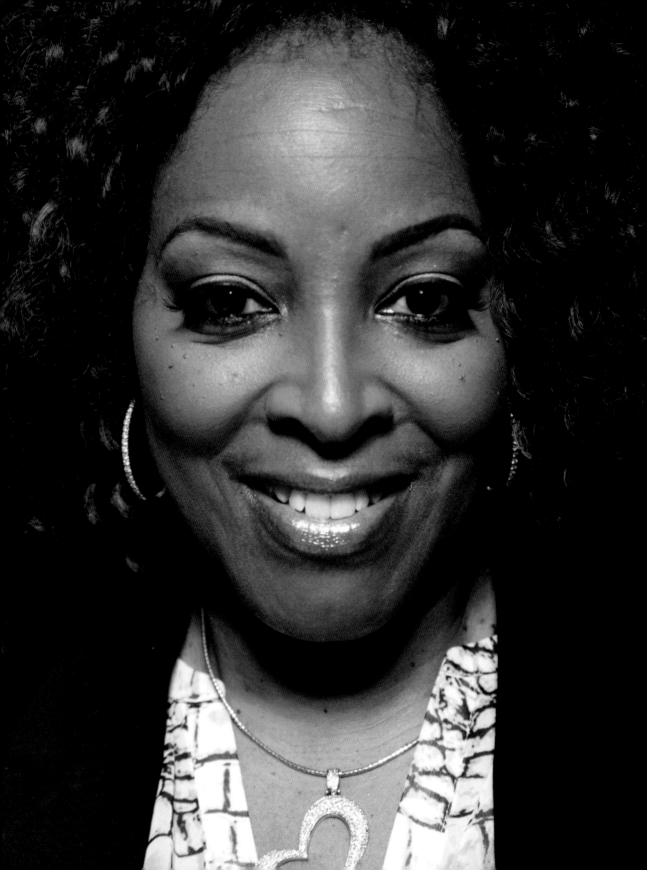

TAMELA CASH-CURRY

ATTORNEY-AT-LAW

The complexion of your skin and the texture of your hair doesn't determine your beauty or your destiny. However, what you do in the skin you're in will define your successes, your happiness, and your legacy. Live *beautifully*!

MORENIKE EFUNTADE EVANS

WRITER, DIRECTOR, AND PRODUCER

We have to stop letting the media give us permission to say dark girls are beautiful—that is *our* birthright.

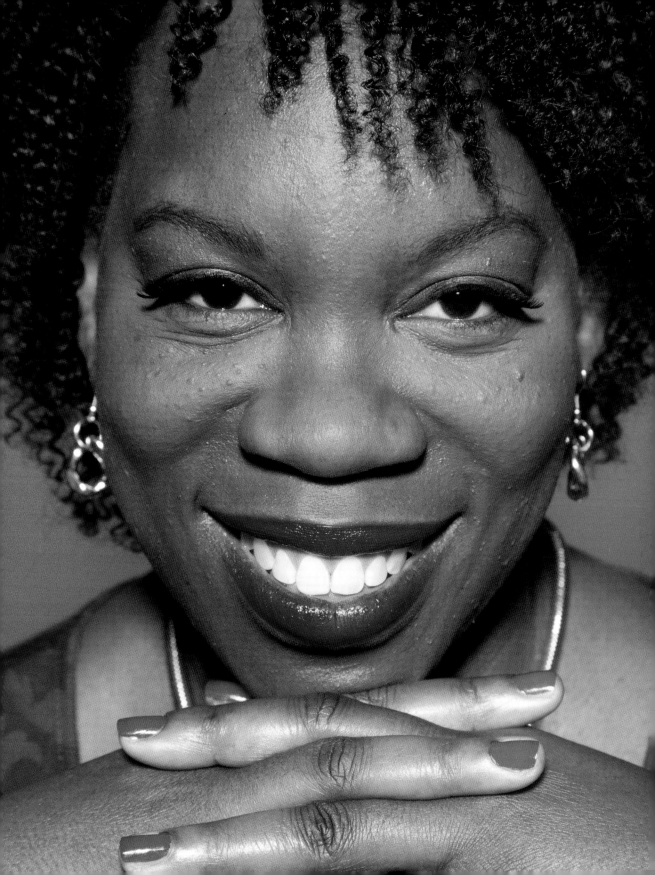

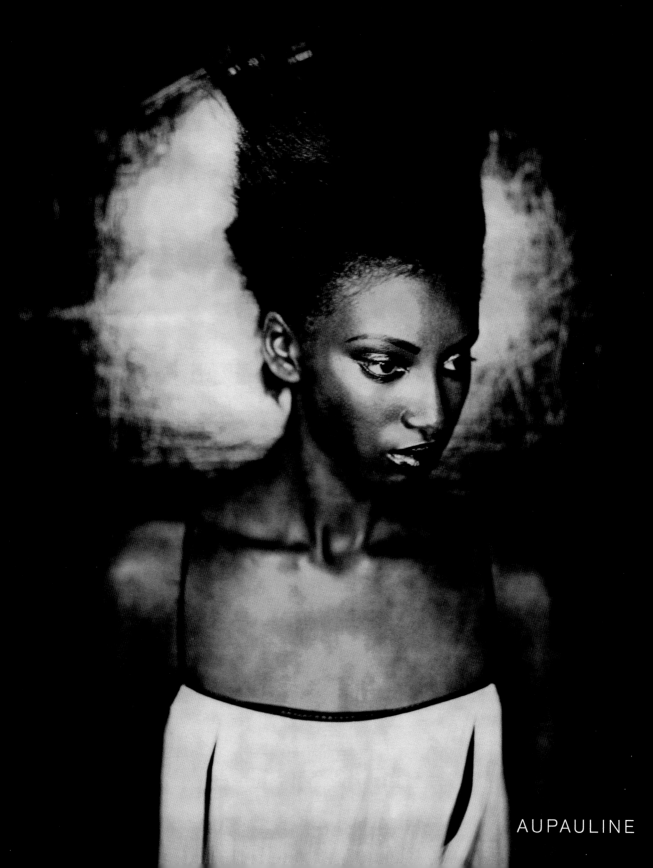

AUPAULINE

ADJI DIAGNE

FLIGHT ATTENDANT

My beautiful dark skin makes me unique.

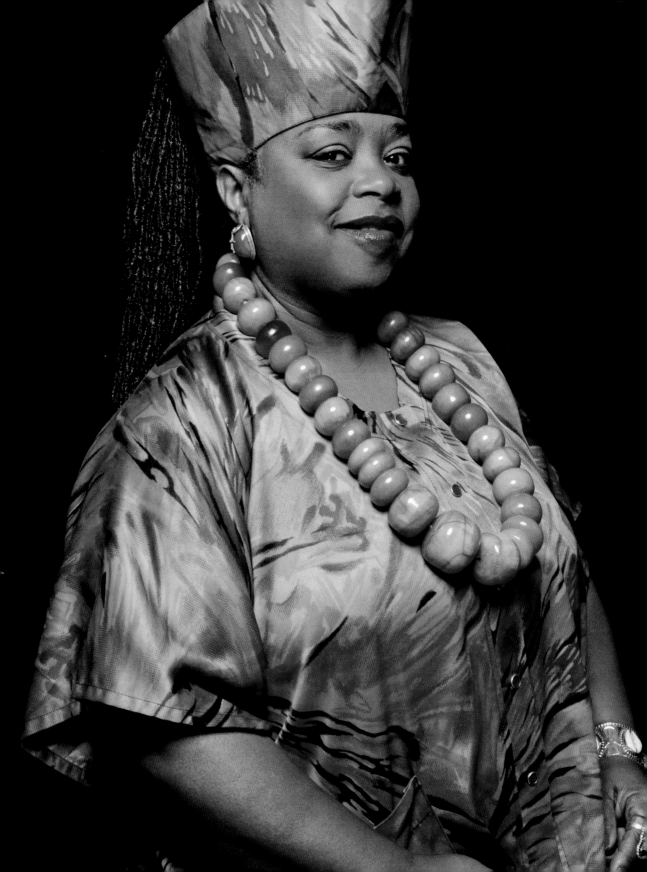

GAIL DECULUS-JOHNSON

CEO OF SABLE IMAGES, INC.

"As dark as Gail" was the phrase people around me used to compare others in the color-struck era I was born into. In the fifties, people in my community really struggled with their darkness. My mother knew my pain, and one day she came home with a big three-foot-tall dark doll that looked like me. That doll was a teaching tool for me to see my own beauty.

Dark does not mean defected.

CRYSTAL R. FOX

ACTRESS

The strangest part of not knowing my own beauty from birth is the fact that the beautiful, black Nina Simone was my aunt. With all of her pride as a dark girl it did not register that it applied to me, too. I wish I had spent more time with her and soaked up more of her darkness into my skin emotionally. Who could have asked for a better teacher about darkness and entertainment than Nina Simone?

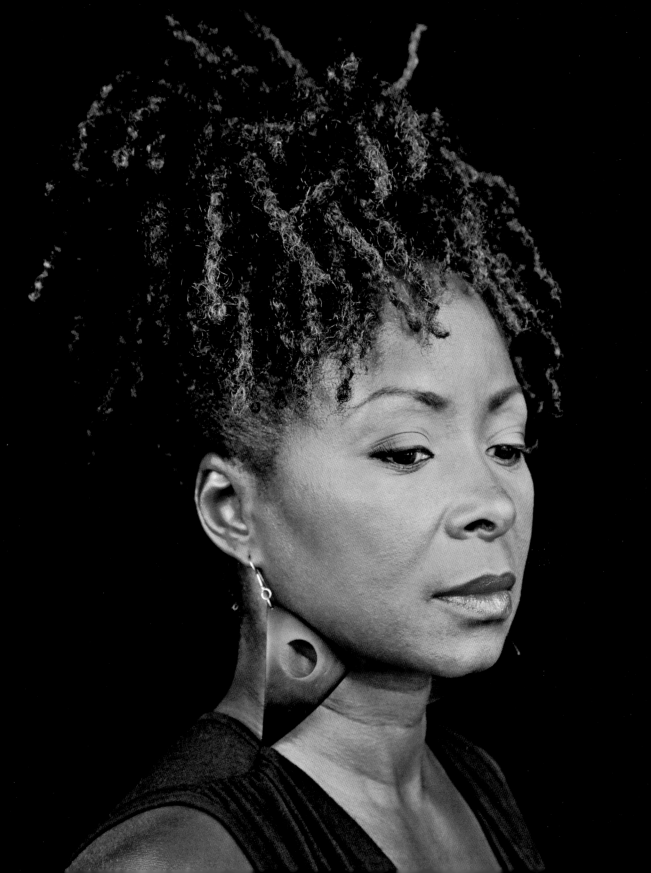

DANAI MARAIRE

ENTERTAINMENT REPORTER AND BLOGGER

I was not the prettiest girl in the room. I was the dark girl who refused to be defined by color or features. I knew I had a beauty that would shine from inside out. I was a very good student and I found myself caught between two worlds. My own race nicknamed me "Oreo," because I talked "too white" and I was in the honors program.

When I arrived at Howard University, I started to truly find myself as the woman God made and as the woman my mother raised me to be. I was not concerned about the crowd; I was betting on Danai and believing in me.

When I decided to be a producer, my long-term goal was to be in front of the camera, but I encountered roadblocks that make me shake my head when I think about them today. Roadblocks like being told, "They were looking for a 'different look.'" A different look meaning light skin and long hair. I understood that, but I did not internalize that—I moved on.

I have been blessed, and I use my blessings to enjoy my career. I enjoy my family . . . mainly my relationship with my mother. I enjoy being a wonderful dark girl.

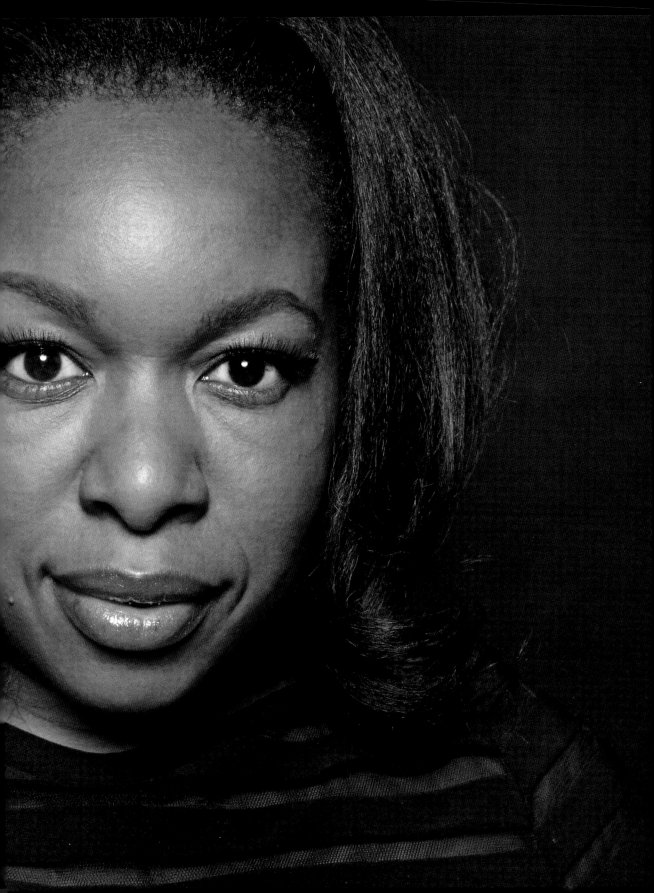

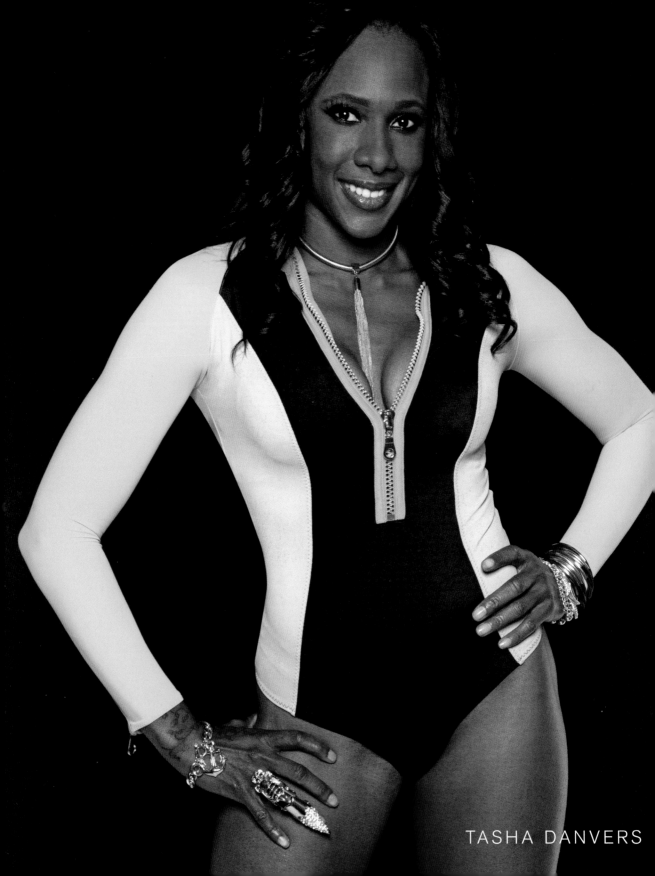

TASHA DANVERS

SOMMORE

ACTRESS AND COMEDIAN

Children do not understand color. That is something we are taught. My grand-mother is very light, and when you are five everybody who is light is white in your eyes. One day my grandmother took me shopping, and she stepped into the dressing room. When I realized we were separated I started to cry. One of the white clerks asked me what my grandmother looked like and I told her, "She is a white woman in a green dress!"

VANESSA BELL CALLOWAY

ACTRESS

I say this with love, but I must say it: There are features that come with being a dark girl that are not appealing to white America and, sadly, they are not appealing to too many black folks, either. Of course I knew this before I auditioned for *Coming to America.*

In fact, it led me to run across the street and buy a long curly wig before the audition. When I arrived, the casting agent said, "Oh, I love your hair," and approved me to the next round. He never said, "Vanessa, you are good." He was caught up in the hair. Then the director said, "I love your hair," and offered me the part that I am best known for today. But you know what? People all over the world know me as Imani. That is the dark girl they love.

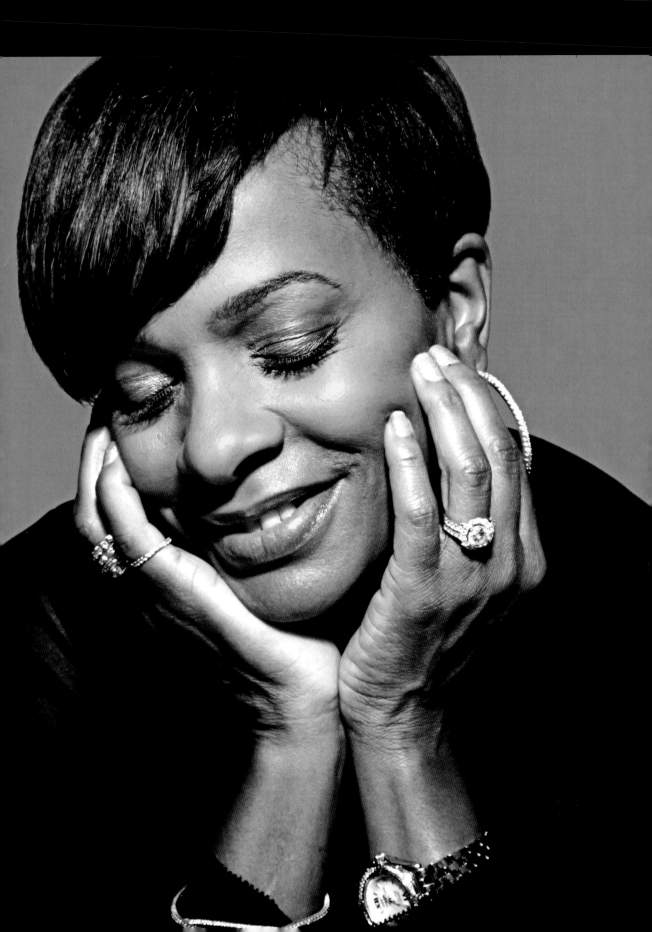

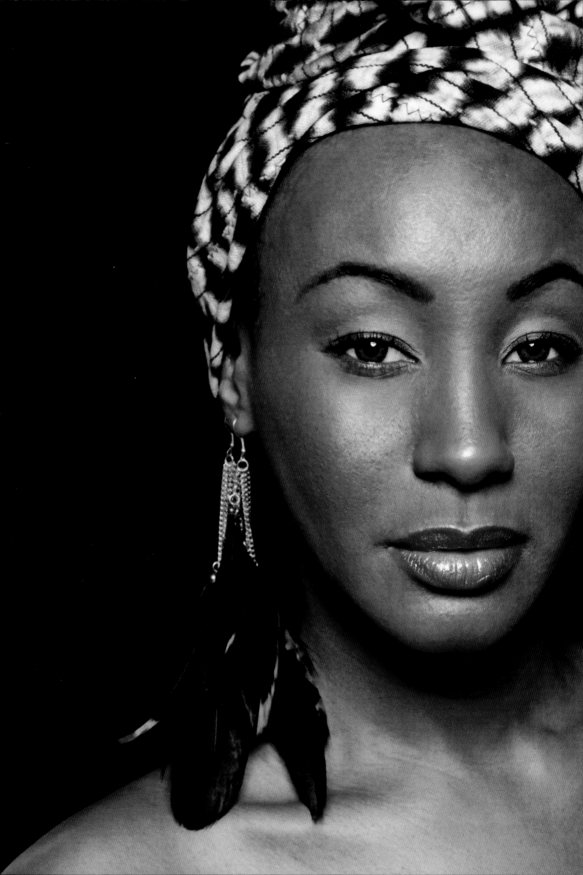

TANJAREEN THOMAS

ACTRESS, PRODUCER, AND HOST

Dark skin, full lips, wide hips, and intelligence. I'm so proud to be a chocolate girl!

JUDGE MABLEAN EPHRIAM

TELEVISION PERSONALITY, *DIVORCE COURT*

Growing up in the hood there were bookies and the-old-guys-with-no-job on every corner. These men looked out for the kids and loved us dearly, but they, too, had a nickname for me, which was simply "Blackie." Just because this nickname was coming from people that I knew loved me doesn't mean it didn't hurt. To my young ears they were saying dark is not cute. They were saying *you* are not cute!

When I became a prosecutor, one of those men from my old neighborhood appeared before me in court. When he saw me he shouted, "Hey, Blackie. I didn't know you worked here." That was a bad day for him, because the judge and his attorney chided him for his disrespectful words. They insisted he apologize and made him address me by my surname. I just laughed, because I knew he meant me no harm. To him, I was still "Blackie" from the hood.

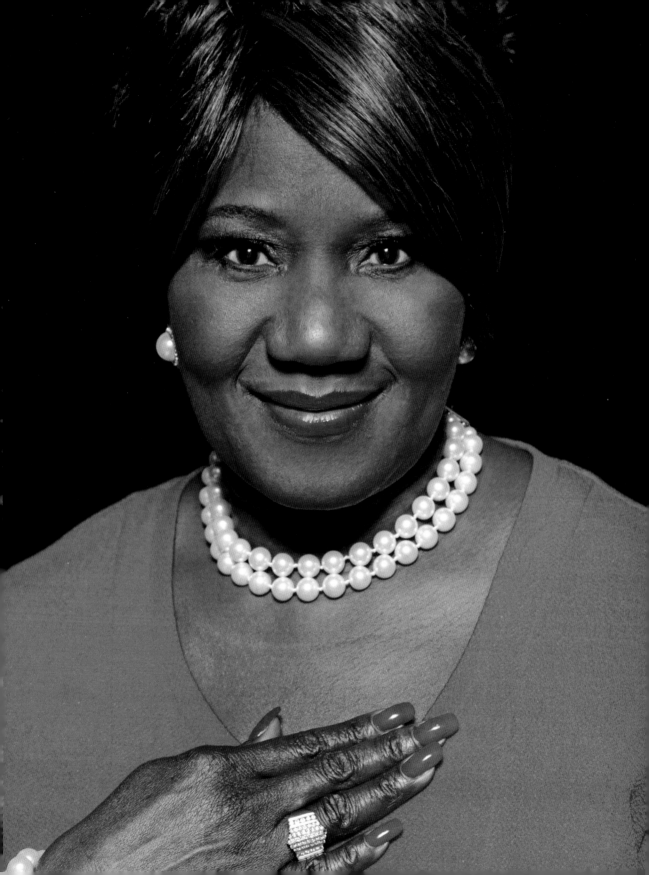

REGINA BROOKS

LITERARY AGENT AND AUTHOR

I have always been a dark girl filled with joy. That joy came from knowing that I was loved from birth. My family was always a source of encouragement. I remember going to dance class and being so excited in my little tutu. Everyone smiled at me and said, "Oh, you are a cute little chocolate drop." Having this nickname was never a negative to me. There is an inner peace you must have to be comfortable in your own skin.

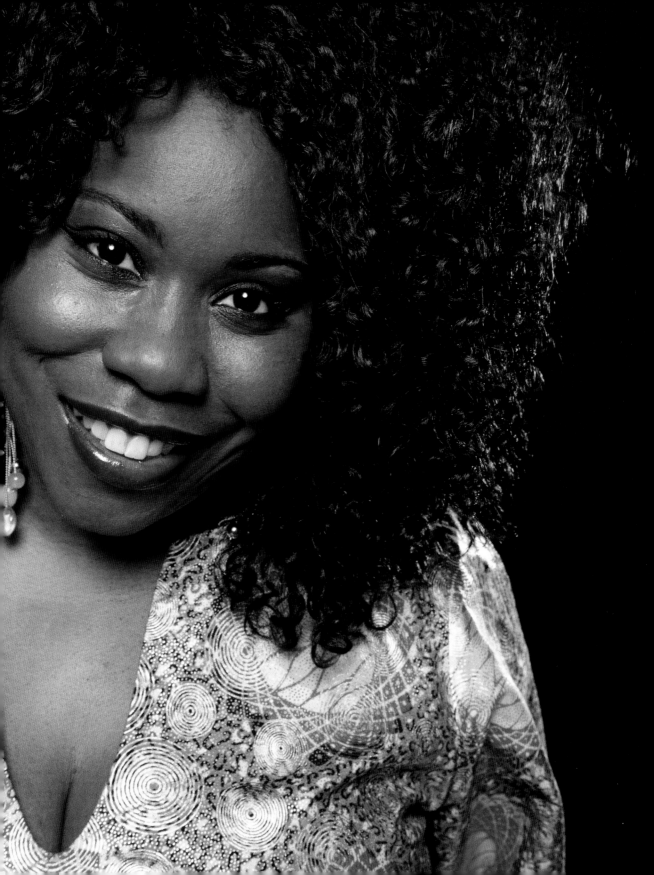

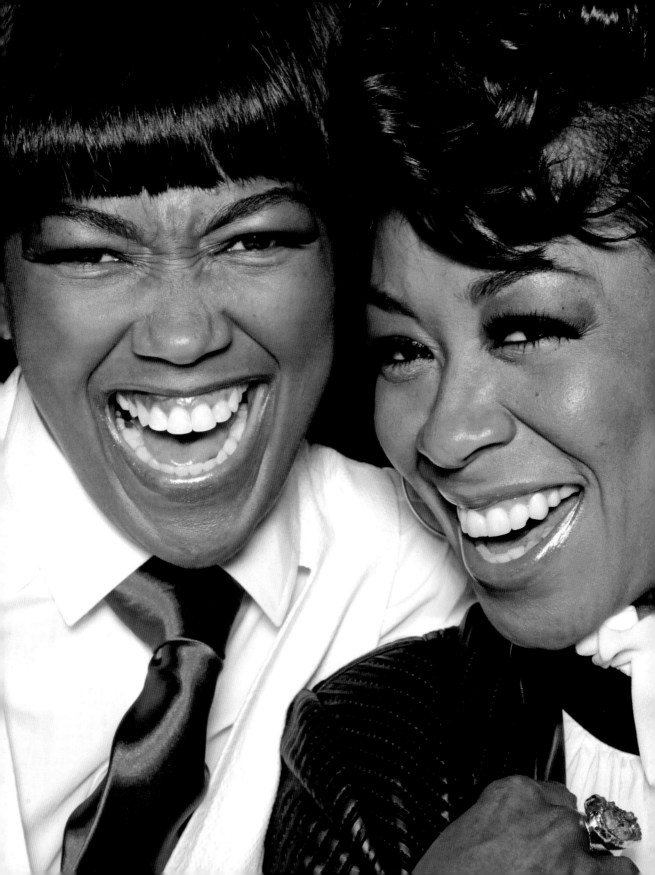

TICHINA ARNOLD AND HER SISTER, ZENAY ARNOLD

TICHINA ARNOLD

ACTRESS

I remember when I thanked Michael Levin for selecting me for the role on *Ryan's Hope*. He said, "You have no idea how hard I had to fight for you."

I told him, "Actually, I do."

I am grateful I am viewed as a talented actress, a talent that others are willing to fight for. Above all, I am a role model my daughter can be proud of. That is what is most important to me, because being a mother to my beautiful dark girl is my real job.

DEMARIS TRIBBETT TOY

GOSPEL SINGER

God created me in His image. What I see when I look in the mirror is God's inter-
pretation of dark and beautiful.

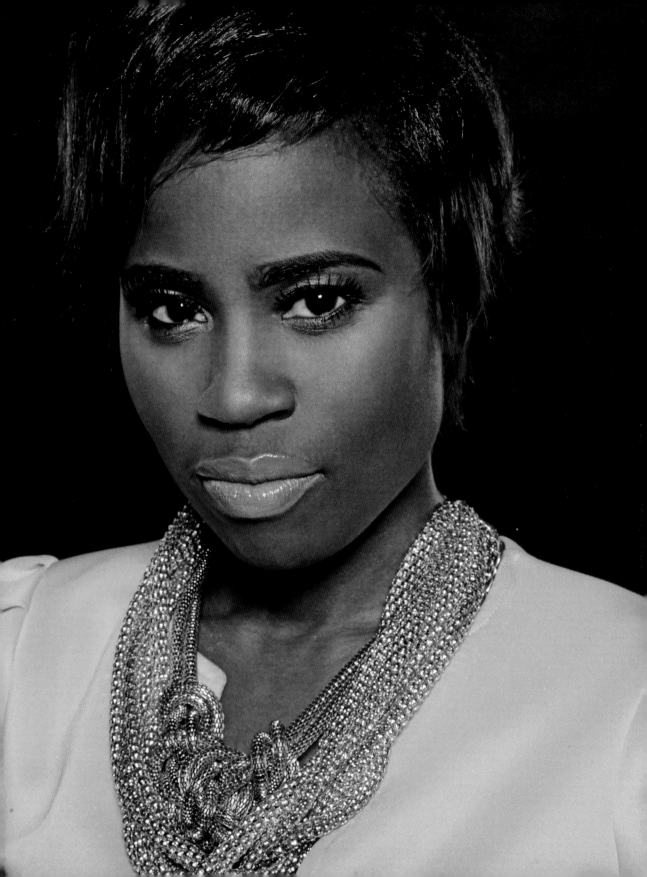

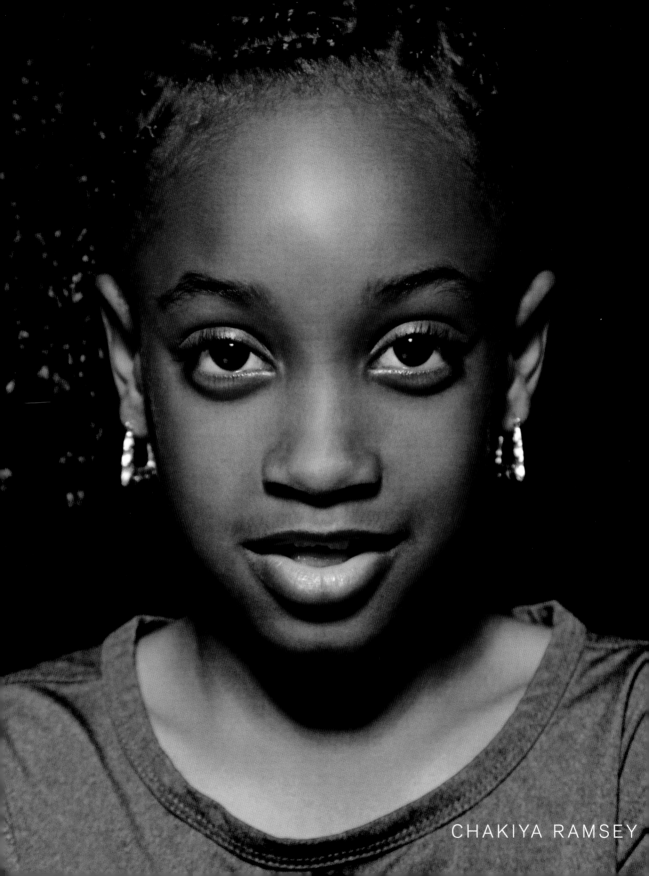

CHAKIYA RAMSEY

MISSY ELLIOTT

SUPERSTAR

I could not be any other color.

In my room is my fifth grade class picture, which is filled with dark girls and boys who looked just like me. When I was in elementary school my teacher would go around the classroom every Friday and ask all of us what we wanted to be when we grew up. My classmates shouted out—"Teacher," "Doctor," "Fireman"—every profession in the world!

When she called my name I shouted, "Superstar." I did not say singer, rapper, producer, or writer. I said, "Superstar."

When I became Missy Elliott the entertainer, I realized immediately that some people in the industry preferred the light-skinned girl with the long, straight hair. Those women are my sisters on this earth, and I have embraced them and hold no ill feelings toward them. I also know that no matter what the industry calls for, you must focus on your craft and your talent to survive what is popular.

I remember having the dark girl conversation with the beautiful and talented artist Tweet. I told her from day one to be proud. That is what I would say to any dark girl. Be proud of your color and move forward with what God gave you. Whatever you want to be, shout it out on Fridays . . . shout it out every day.

SYLVIA OBELL

WRITER

The world is my oyster. I am a twenty-four-year-old dark girl and perfectly happy in this dark skin. I feel empowered, and I refuse to live in a world of sorrow based on skin color, but I do understand the plight of my sisters.

I must say that black women have not been kind to each other as it relates to our skin color. I am amazed at how the light-skinned sisters do not realize that the men prefer them when we are all in the same room. We do not have that conversation as beautiful women of color.

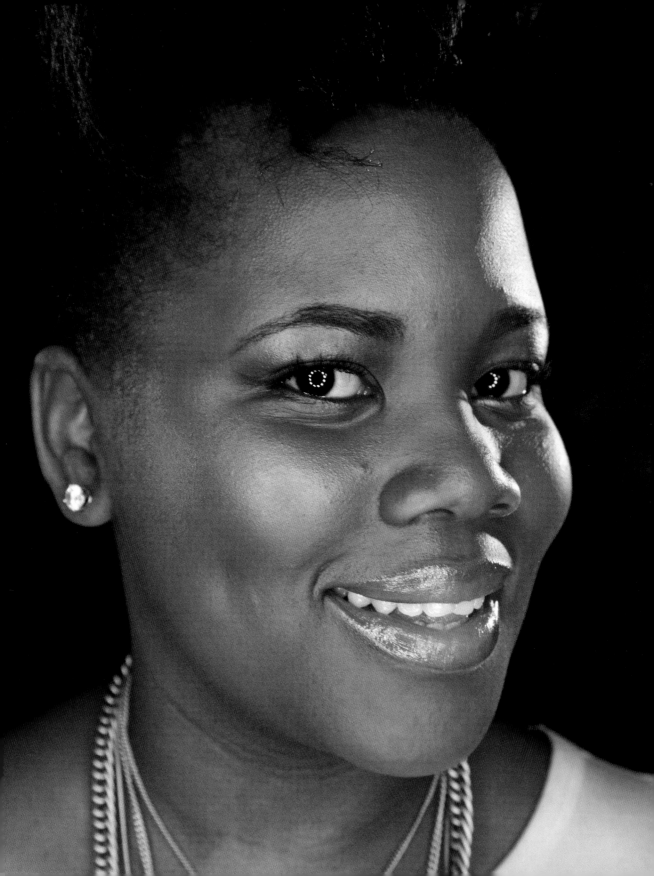

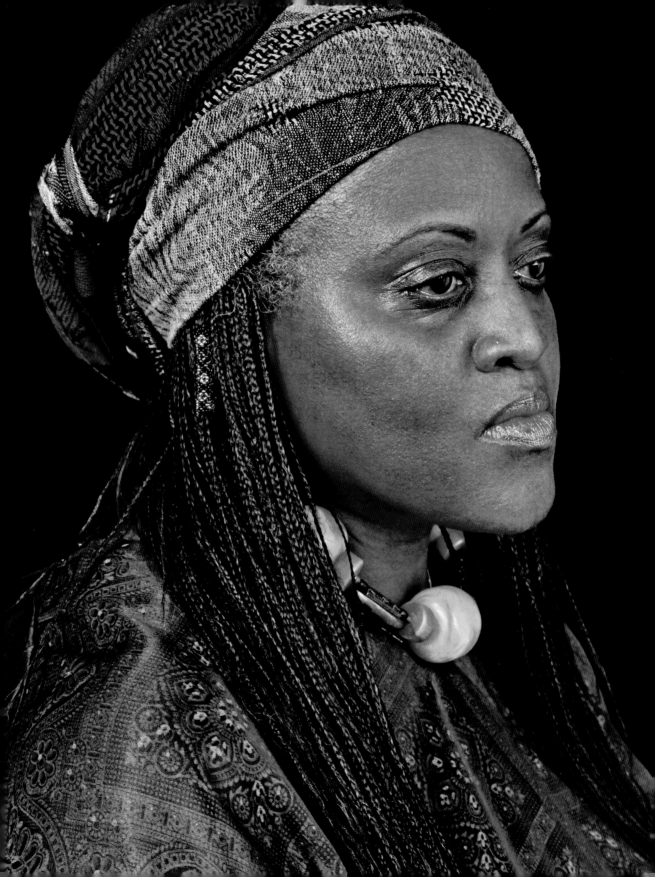

DONNA KINSLER

MARKETING MANAGER, HUMAN RIGHTS ADVOCATE

Never allow that which is not true to hurt you. Be enlightened, dark girls.

CYNTHIA BANKS

MAKEUP ARTIST

My mother was light enough to pass for white. She gave birth to three light-skinned children and one dark-skinned me. She was so kind and good—the best mother in the world. My mother went out of her way to protect me from people who cared that I was darker than her other children. She knew before I did that the world would be unkind to me.

Thank God, I was too young to remember the day she was in the five-and-dime store and a white woman walked up to her and said, "What are you doing with that little baby?" I always wondered which aisle my mother left her Southern manners on when she gave that woman a piece of her mind.

Southern white women were not the only people who have been unkind to my dark skin. I was a grown woman living in New York when I started dating a brother who I thought really liked me. We were walking down Fifth Avenue one night when he stopped and looked at me. He said, "You are so beautiful and smart. If only you were light skinned. You would have the world."

My heart still hurts for him! That was our last date, because I love the dark skin I am in. It is because of that I do have the world.

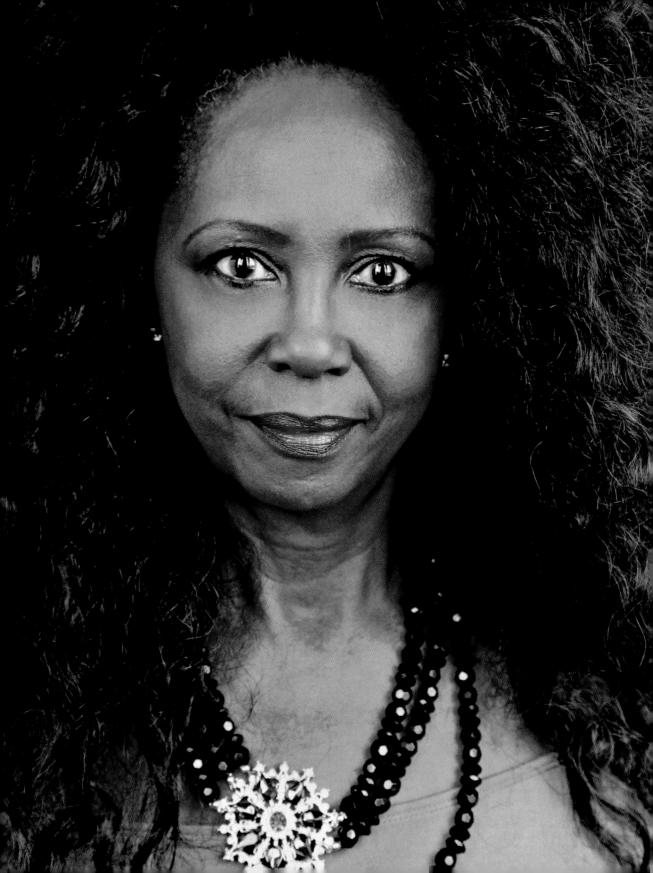

NADIRA MOORE

EIGHTH GRADER AND AVID KNITTER

We live in a really cool place in New York. My bedroom is my favorite room in the house because it is shaped like a castle, and when I walk into it I feel like a princess. I couldn't wait to show my room to my friends. When making the guest list I didn't even think about the fact that my friends were white, black, and African.

I cried when my white friend declined my invitation. She explained that she could not be around that many dark-skinned people. At that moment, I understood what racism meant.

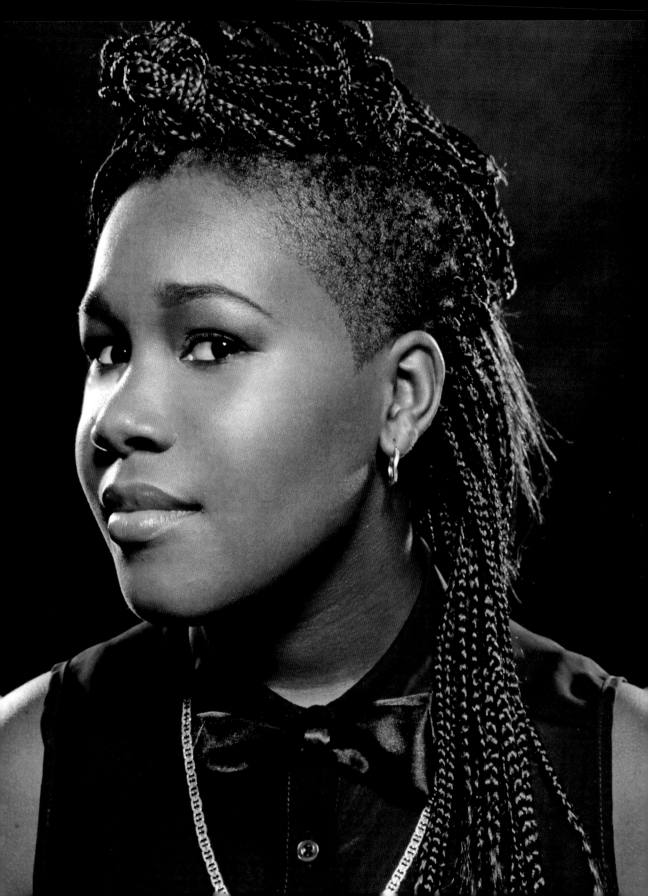

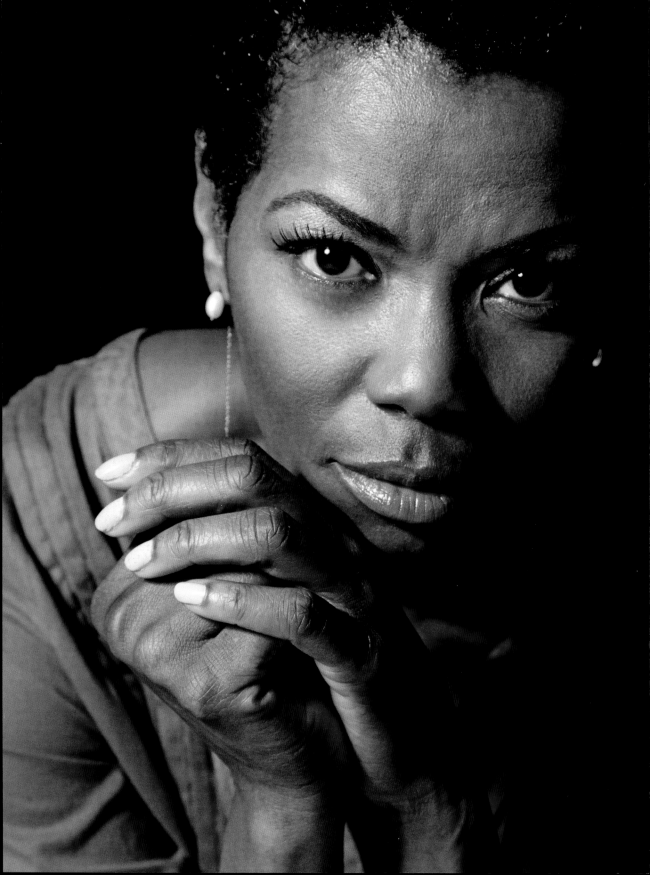

VANESSA WILLIAMS

ACTRESS

When I was a little girl I remember my grandmother frying my hair with the pressing comb. Not having straight hair like many girls might desire is part of being a dark girl, but it was not something I longed for. I learned early that the hair, the wide nose, the hips—it's all part of our beauty. I have embraced my beauty and love the skin I am in.

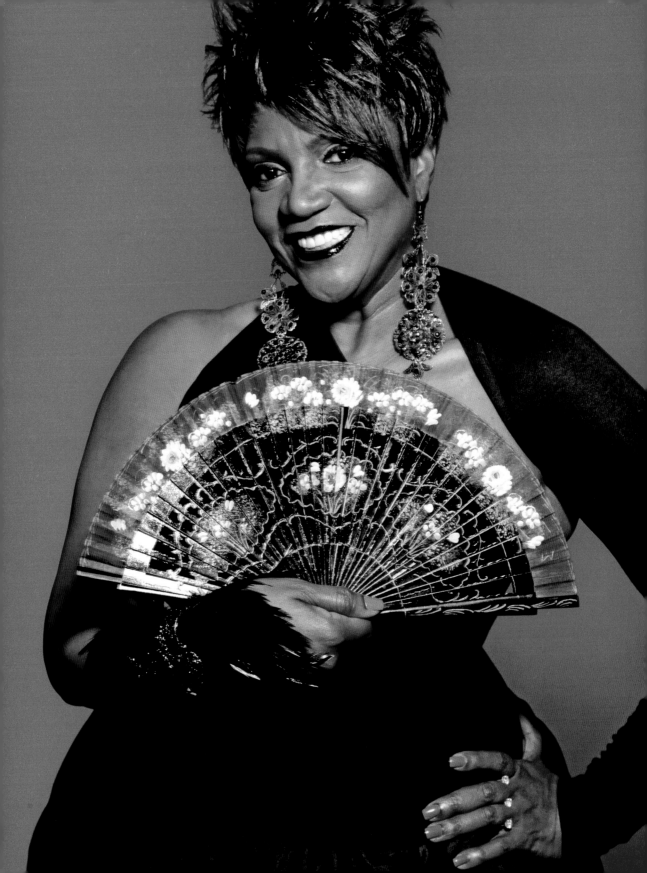

ANNA MARIA HORSFORD

ACTRESS

Where is your wall? We should all have our own wall, no matter how small, to fill with pictures of ourselves in order to praise the gifts that God gave us. When I was growing up in Harlem my parents had the walls filled with family photos and pictures of us as babies. Those pictures told our story. When I walk by that wall my ancestors shout, "You are beautiful."

Before I left those walls my parents made sure I was prepared for the world. I understood that this dark girl could, and would, be a success. I walked into show business and was not afraid. I knew what I was getting into and I knew the color of my beautiful dark skin would not stop me.

It's a big world out there, filled with people who want to hurt you if you let them. Don't let them in. Dark girls, protect your wall and keep hanging portraits that remind you of how beautiful you are.

AYANNA GREGORY

**ACTRESS, JAZZ SINGER,
AND DAUGHTER OF CIVIL RIGHTS ACTIVIST DICK GREGORY**

Our home was filled with blackness. When my dad, civil rights activist Dick Greg-ory, came home from a gig or from marching, he filled the house with civil rights stories that fueled my blackness with pride. In addition to my dad's stories, the halls were filled with pictures of African Americans. Those images of black folks stayed with me when I went out into the world. I am grateful for those pictures, because when I walked out the door the white children in Plymouth, Massachu-setts, greeted me with unkind words. But I was unshakeable.

As a daughter of the movement, I have the opportunity to tell the story of my father's fight for freedom in my one-woman show. I have the opportunity to talk about my mother being kicked when she was pregnant with twins during a march. Through it all they are not bitter, so as a dark girl I have no right to be bitter. I am a product of the movement. A product of the struggle. No darkness or light can change that.

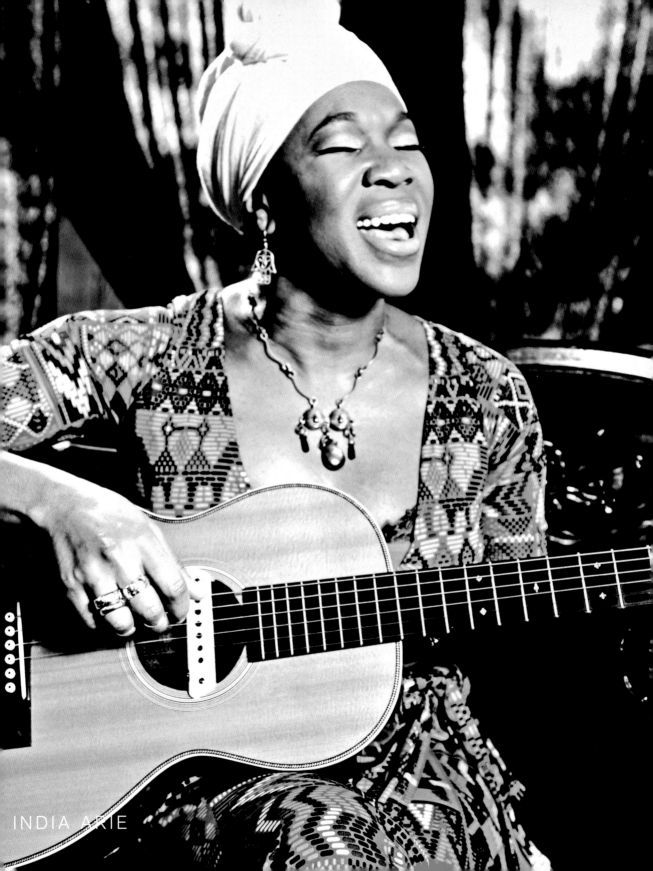

INDIA.ARIE

MIKKI TAYLOR

EDITOR-AT-LARGE

Our time has come, dark girls. Our time has come!

Power moves from generation to generation. I was born to a beautiful dark girl, who, as the best entrepreneur in our family, earned a living by making other women feel and look gorgeous. Two generations from slavery, she was part of a line of strong, empowered women who stood in their truth and owned their beauty to the fullest. Their love, their power, serve as the source of my strength to this day.

My mother was a salon owner and award-winning hair stylist in Newark, New Jersey. Sitting with her all day was a master class for me. I watched her physically transform women as I listened to every word that came from their beautiful full lips. In addition to her destination salon, Mother traveled all over the world with the great Sarah Vaughan as her personal hair and wardrobe stylist. Her relationship with Sarah gave me a front-row seat to witness history.

When Mother was off the road and at the salon, it was like being in a dreamy movie where women were in charge! The women talked about hair, politics, recipes—you name it. Most of all, I saw their pride in their race, their faces, and their hair! They loved themselves. The salon, the women, our city, were all inspirational to me, so much so that it gave clarity to my purpose of helping women own their lives and celebrate their beauty—all shades, shapes, and sizes—in full.

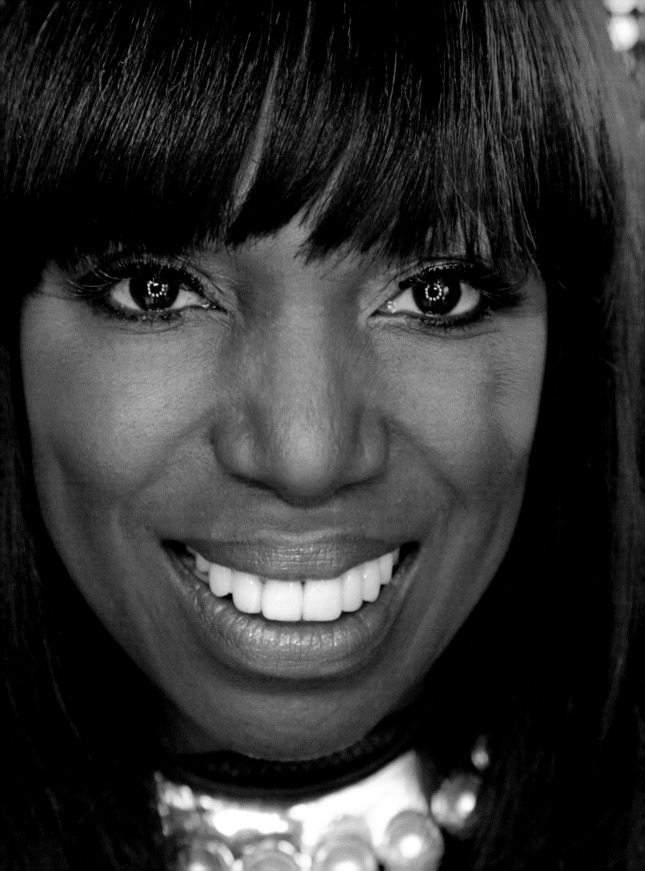

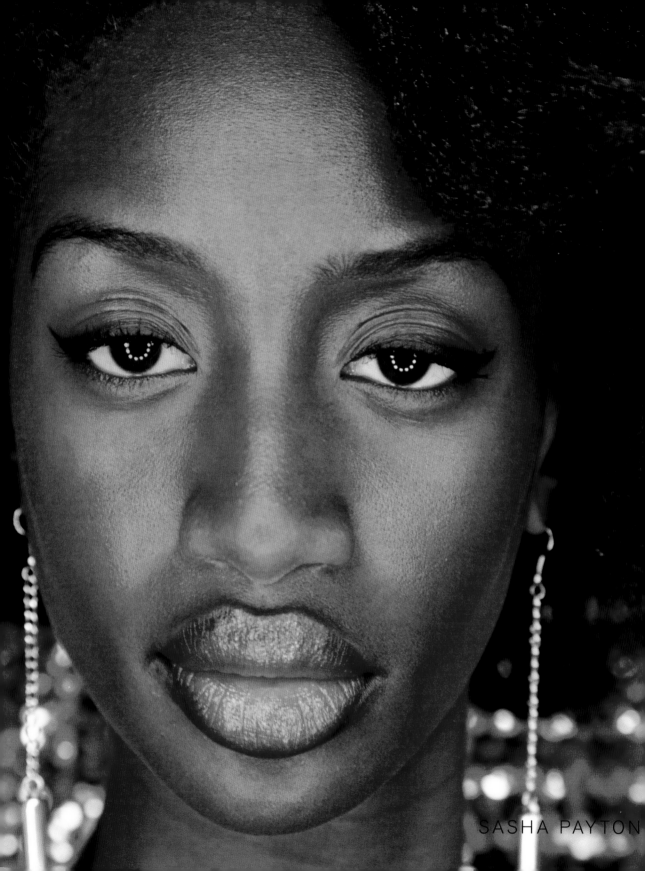

SASHA PAYTON

ANDRA HALL

FOUNDER AND CEO OF CAMICAKES, LLC

One day I was talking to a friend who was also pregnant and I told her that I hoped my daughter would be born brown like me. Her response was, "I hope not, because people with dark skin look dirty to me." Her statement was unbelievable because her husband is very dark, and it was just a sad thing for a woman of color to say.

When my daughter Cami was two years old, I started CamiCakes and intentionally used pink and the color of chocolate as my signature company colors. I used the logo of a little dark girl that looked like my baby, my child. I wanted other little girls to walk into CamiCakes, not just to purchase a cupcake, but to relate to their skin color. They are not dirty; they are beautiful. My goal is to raise a proud woman of color. CamiCakes is part of that!

"There were no dark girls on TV and no dark-skinned dolls in the stores in Cleveland, but my mother filled the house with *Ebony*, *Jet*, and *Essence* magazines."

—CARLA B. FERRELL

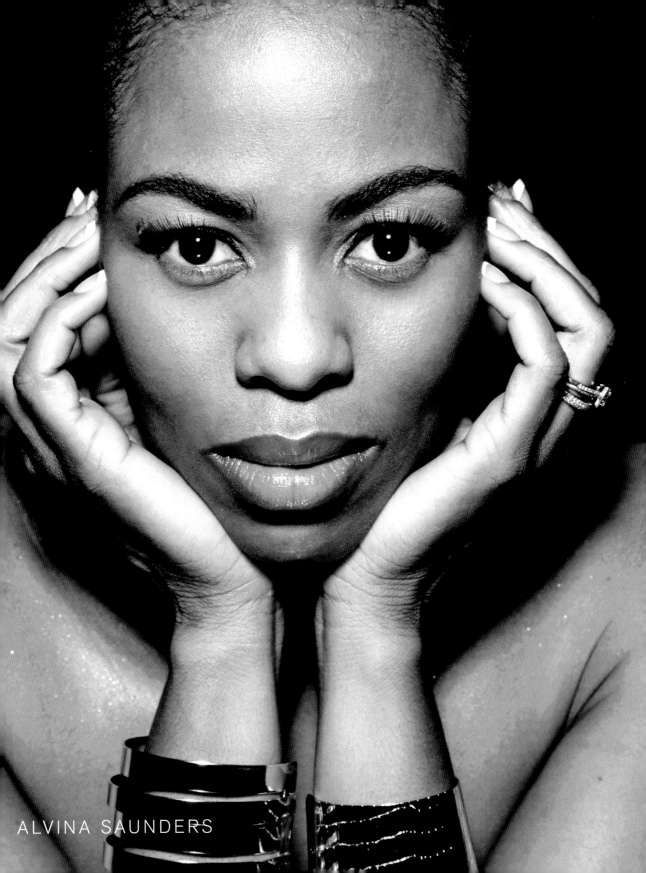
ALVINA SAUNDERS

LONI LOVE

COMEDIAN AND ACTRESS

Throughout my childhood I did not want to change the color of my skin. I knew, understood, and accepted that I was not the light-skinned girl with the long hair. I have always wanted to be a comedian. I was focused on women who had gone down the path before me. I had Cicely Tyson and Esther Rolle to look at and say, "They look like me."

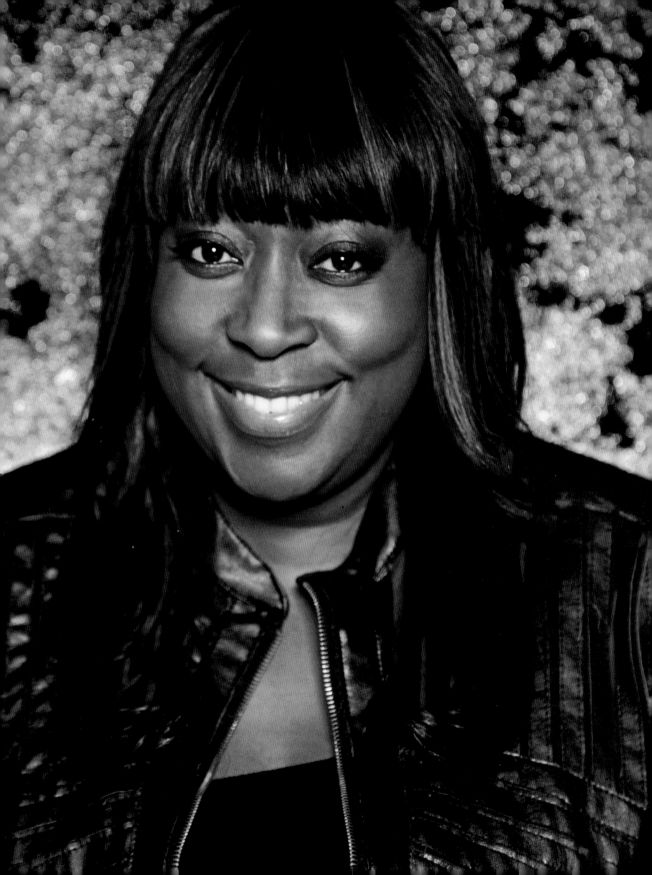

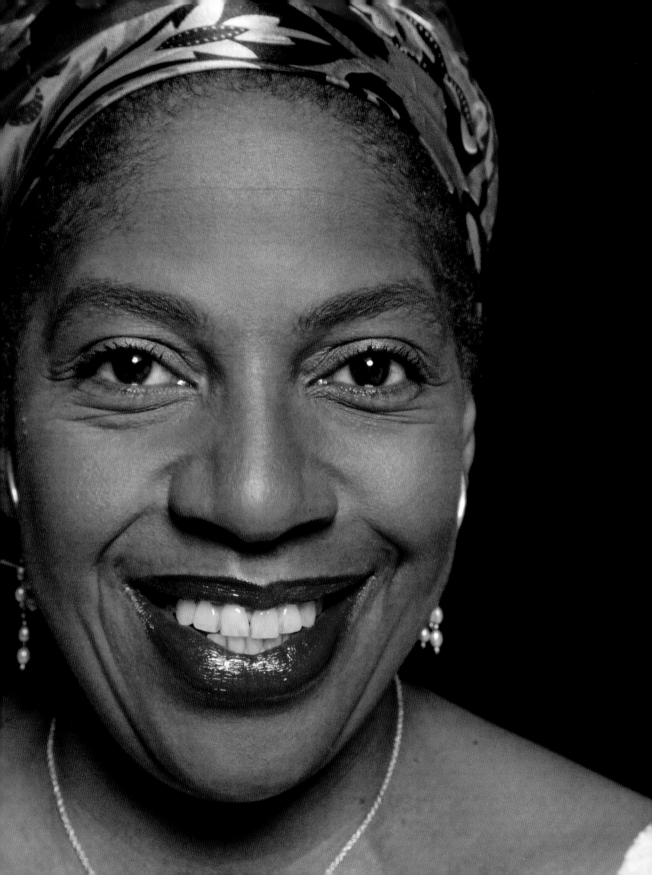

AVA DUPREE

JAZZ SINGER AND ACTRESS

As a child, I would pick up the newspaper and read about the conditions of black people in the South. I was upset at the fact that people were poor and looked sad in the photographs. So I thought it was negative to be black and really negative to be black and dark.

Over the years I grew to love theater. I remember when I was in a play and one of the cast members said, "You would be so pretty if you had a thinner nose and smaller lips." That was the same as saying, "You are too dark." She really thought she was complimenting me.

I remember dating this white guy. I boldly went to my boyfriend's parents' home for dinner. His dad was supernice to me. During dinner, he looked at me, and in a normal voice said, "I wish all black people were like you." He kept eating. His facial expression never changed. He, too, thought he had given me a compliment.

PHINA C. IHESIABA

YOUTH PROGRAM COORDINATOR

People really do not understand how hurtful it is when they describe you by your skin tone. I am not just talking about strangers. I am talking about family members. Because I was the darkest child, my family referred to me as the darker sister. It was so natural to them. I had nicknames like "Blackie" and "Booty Scratcher."

To combat those nicknames, I stepped into my skin and embraced it. I made myself feel like a beautiful dark girl then, and today is no different. I live my life as a proud dark girl without acknowledging how others describe me.

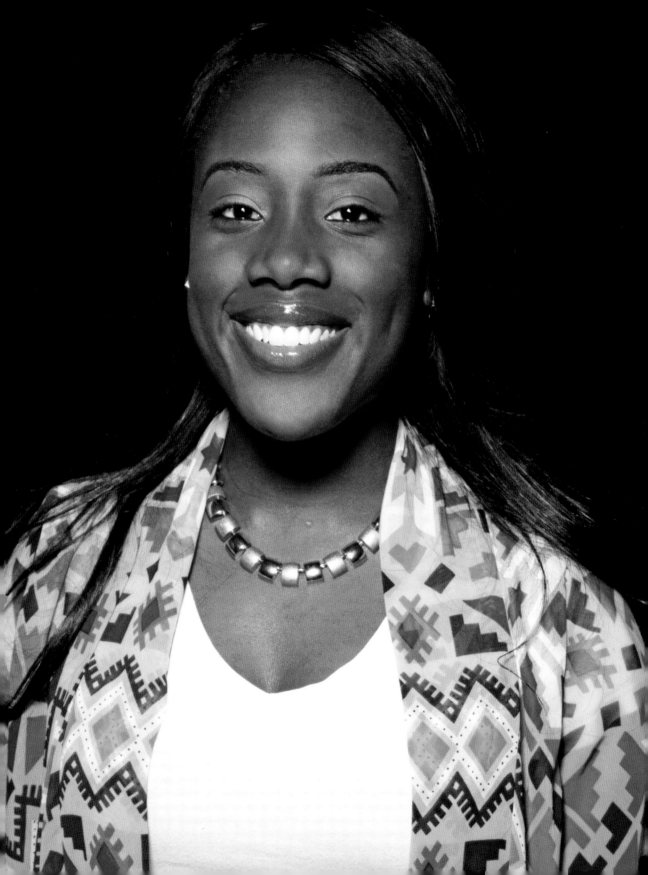

"My dark skin is like the red clay of the earth: naturally beautiful." —PAM WHITE

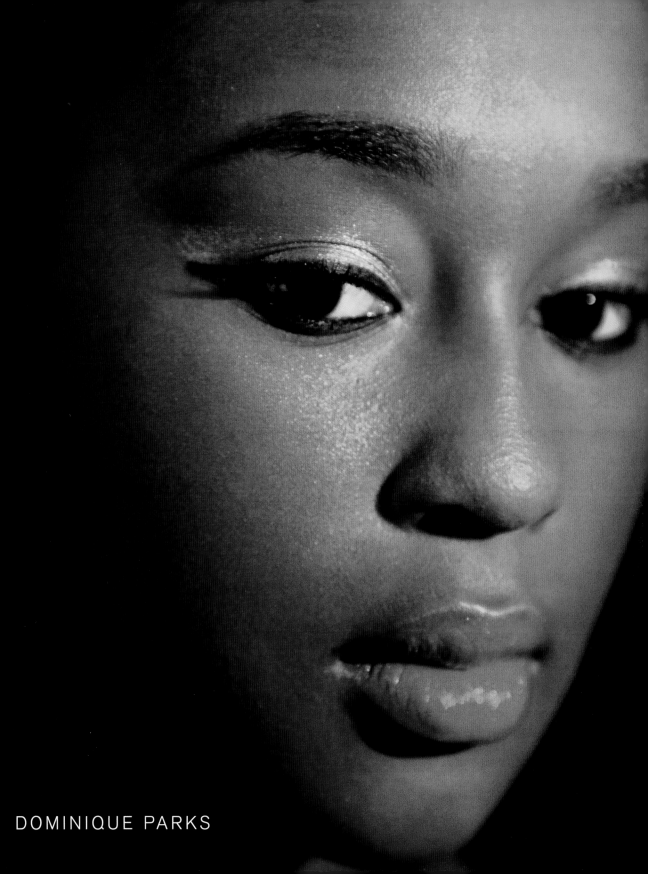

DOMINIQUE PARKS

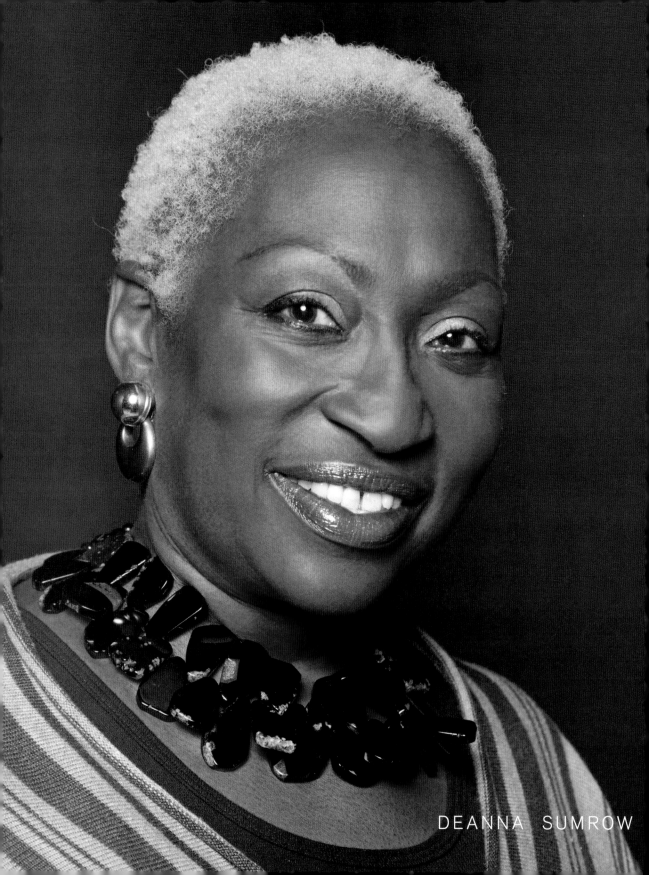

DEANNA SUMROW

PHYLLIS YVONNE STICKNEY

ACTRESS, ACTIVIST, AND COMEDIAN

I draw my strength and beauty from God and a place called Dark Shadow in Tennessee, where I was born and raised. Nothing is more beautiful than that place and my family.

Our house was filled with dark girls and dark boys. I had a dark mother and father, so darkness was perfectly normal and beautiful to me. I was darker than everyone in the house, and people openly referred to me as the darkest, but that did not bother me.

When I went to Hollywood I learned not to be upset when the roles went to the light-skinned girl. It is not her fault that she is preferred. I am not upset that our black men prefer the light-skinned, long-haired girl. That is what they were taught. It takes a special black man to love a dark girl, and a special dark girl to love herself.

CHANELLE HAYES-SCHWARTZ

SINGER AND MODEL

I did not always know that my darkness was a blessing. I knew that Grandmother Eldora's high cheekbones carefully placed on my face made me unique, but it was Grandmother Shirley's strength and pride that helped me see my beauty. I did not always feel pretty, even after I became a professional model. I had such a complex about my color that I found myself actually hiding behind a pair of big sunglasses before a fashion show.

A few years ago, I noticed it was taking the makeup artist forever to finish my makeup, and I just started to cry. When she asked me what was wrong, I told her I noticed it was taking her longer to do my makeup than it took to do the other girls. She looked at me and said, "It is taking me longer because I noticed the symmetry of your face from across the room and wanted to take my time and experience your face. That is why I requested you."

That was the rebirth of the new Chanelle.

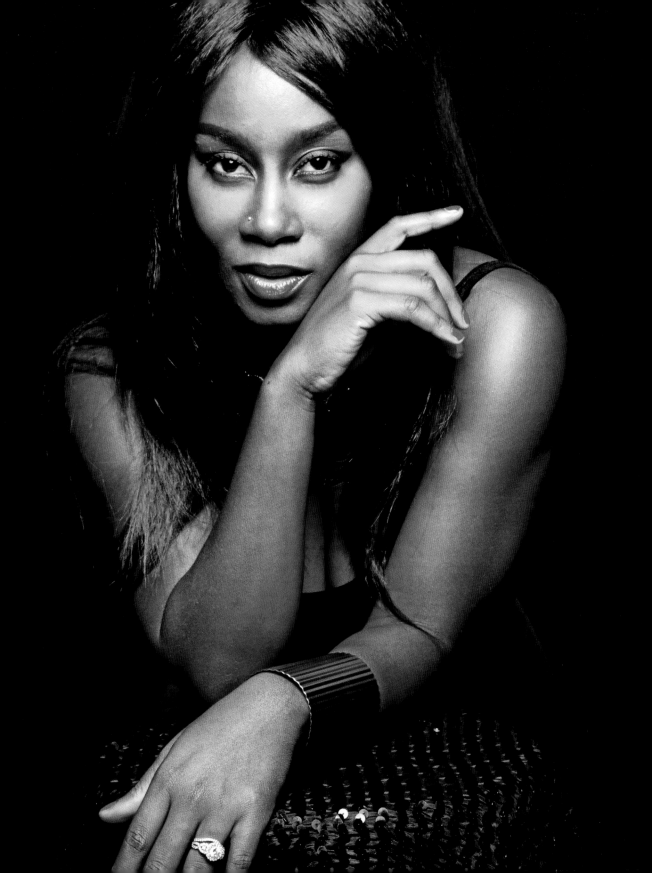

"When I look at my beautiful and special dark girl, I see someone who has already made a difference in this world: a child who sees no boundaries on what she can accomplish and has the determination and willpower to be stellar." —JADA HOLCOMB

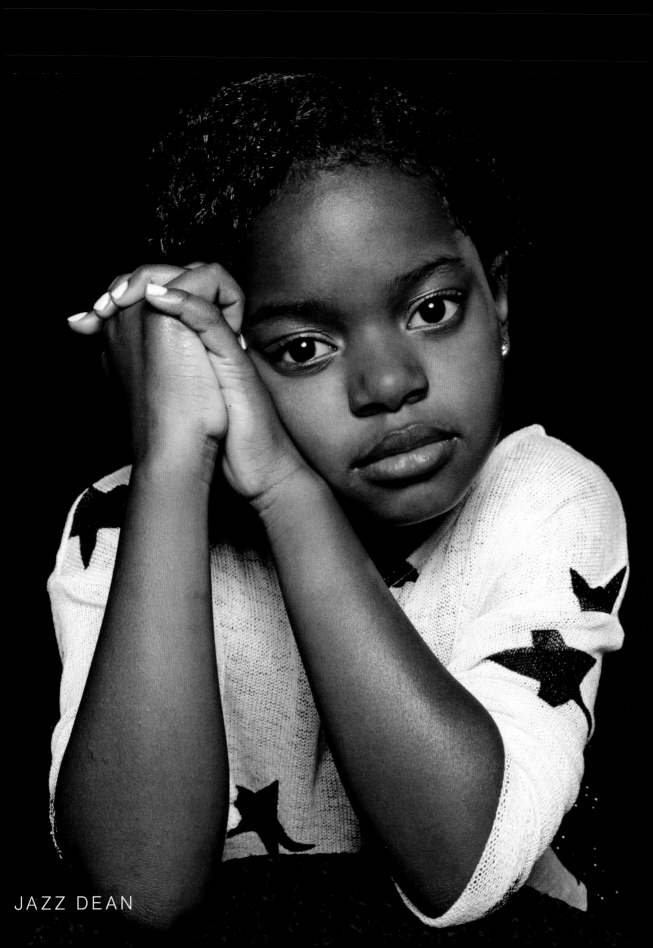

JAZZ DEAN

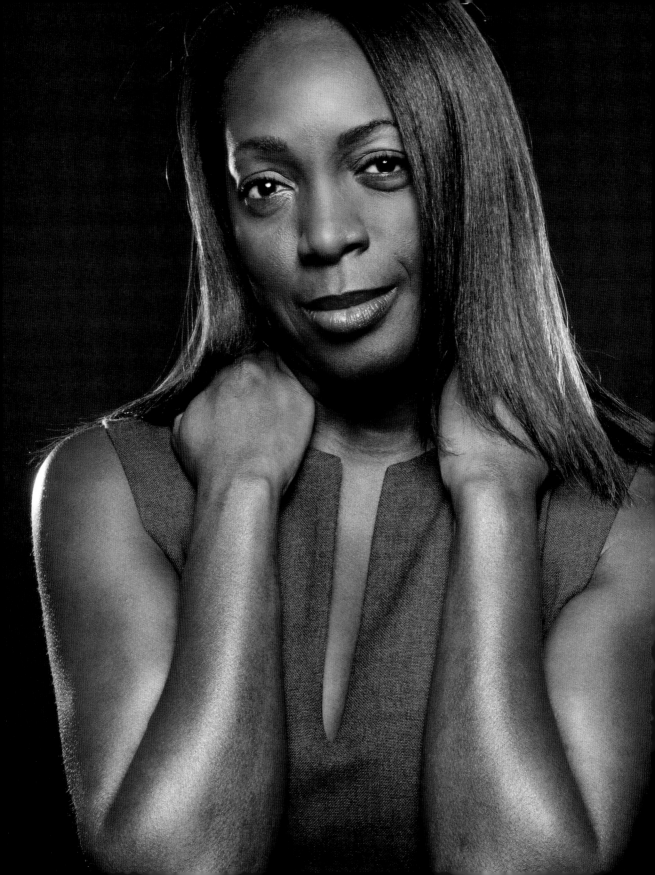

TAMARA HOUSTON

PRODUCER

While my mother went inside a store she allowed me to pump the gas. I was happy because it was my first time and it made me feel grown up. An elderly black woman was pumping gas beside me and struck up a conversation. In the midst of our chat, she said, "You are so well spoken for a girl of your hue." *Hue? What is a hue?* I did not know the meaning, but I knew it was not good.

My mother filled our home with books, such as *The Souls of Black Folk,* by W. E. B. Du Bois, and books by other black authors like Langston Hughes and Zora Neale Hurston. In addition to reading books, I loved flipping through *Essence* magazine, uncovering my beauty as a dark girl by looking at women of my hue. I carried the spirit of those women with me to my first job on Seventh Avenue in New York all the way to my position as president of ICON MANN. I have no misgivings about the dark girl who I am.

I am a woman wonderfully formed of purpose, potential, and vision.

DR. TENIKA JACKSON

CLINICAL PSYCHOLOGIST

I am a dark girl who will change the world by helping one girl at a time.

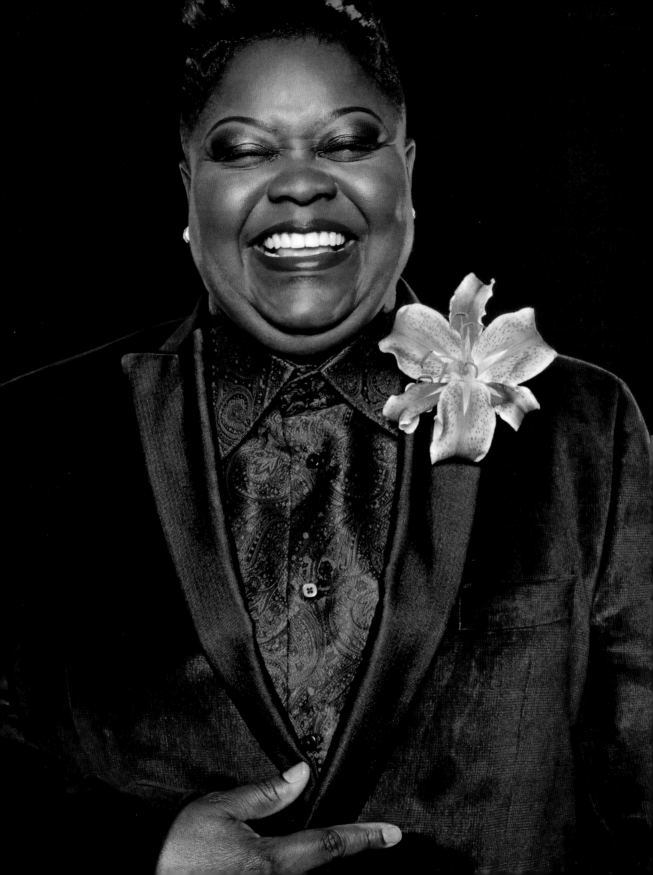

LORETTA DEVINE

ACTRESS

Being a dark girl is not easy for so many women. For me the love I felt as a child outweighed that. My father and mother were not together, but my father came to visit me all the time. He showed me love as did my brothers. When I started dating I walked out into the world knowing who I was as a woman and what I deserved as a woman. Show business was a test of my faith, but God sent Gregory Hines into my professional life. He was my first love interest on Broadway and my first love interest on the big screen. I remember the day we started filming *Waiting to Exhale.* When we arrived on the set I had a big bouquet of flowers waiting for me from Gregory. I felt like a queen. Once again, it was God saying, "You are loved, Loretta." That's what I know as a dark girl. I am loved.

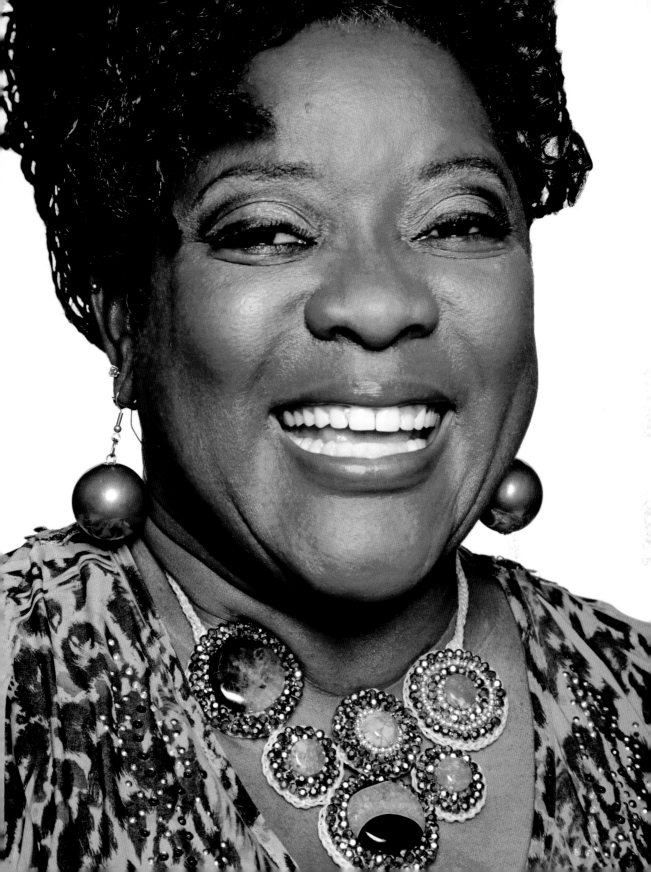

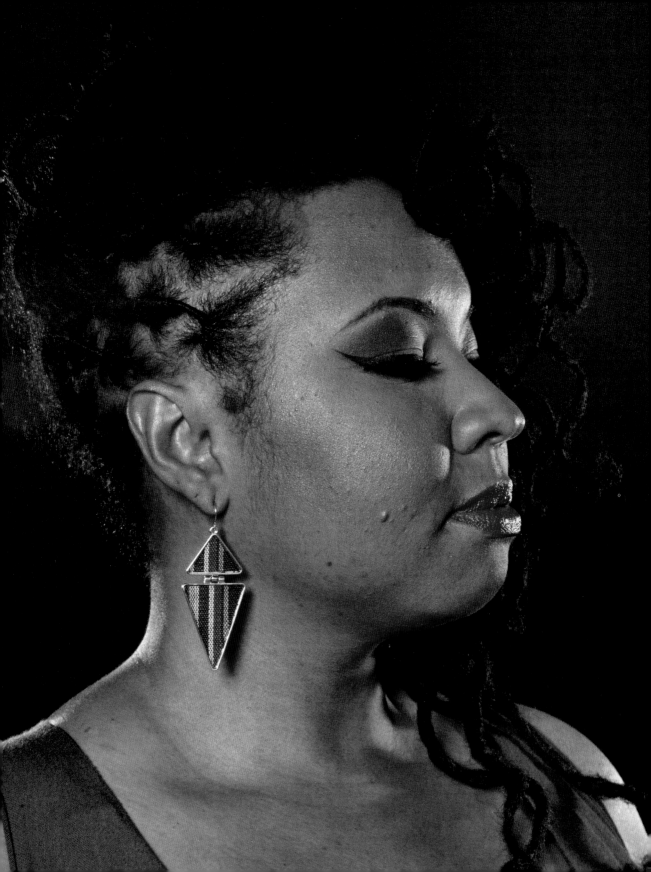

FAYEMI SHAKUR

WRITER, CULTURAL WORKER, ACTIVIST, AND YOGA TEACHER

I am a beautiful dark girl, because I reflect the wisdom and love of my family, teachers, and ancestors. I am dedicated to exploring life with joy, devotion, and compassion.

The first lesson I learned as a dark girl was taught to me by my mother. Her mother died at the young age of twenty-six and left six children behind. My mother and one other light-skinned child were taken in by my family members. Sadly, the darker siblings were placed in foster care. Imagine growing up knowing you were given to strangers because of the color of your skin. By the grace of God, my mother and all of her siblings stayed in touch, and we are a family today.

TAJAMIKA PAXTON

FILMMAKER

Born dark, fearlessly and wonderfully made.

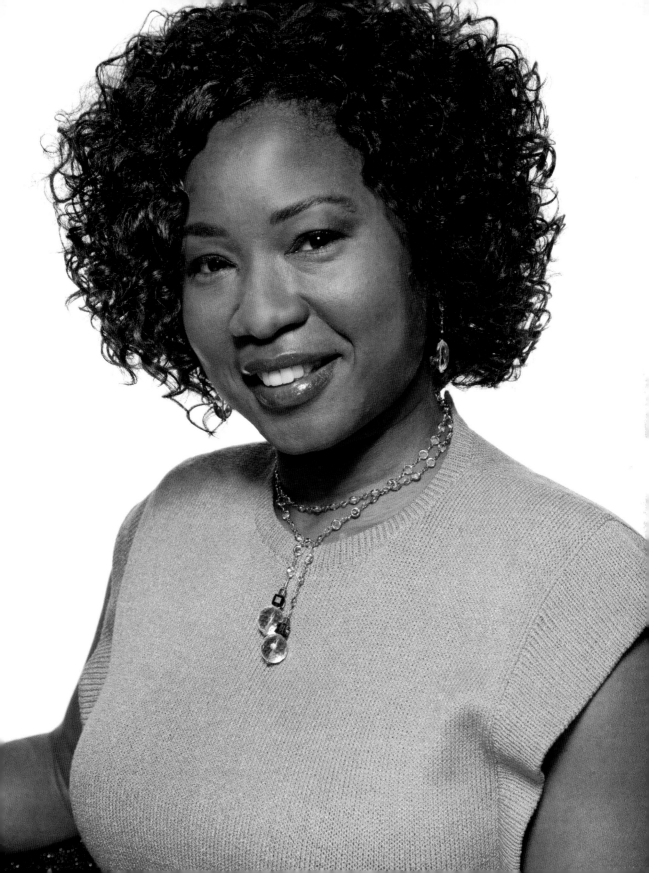

DAWN HARPER-NELSON

OLYMPIAN

Dark girls, be proud.

When I won at the 2012 Olympics, everything inside of me was tested. It was amazing to hear the sportscasters call my name. It was also very difficult to listen to them say I was the black girl from the struggling city of East St. Louis. Black girl, Olympian, and East St. Louis were a hard mixture for many people. It is my job as an Olympian to turn that into something positive.

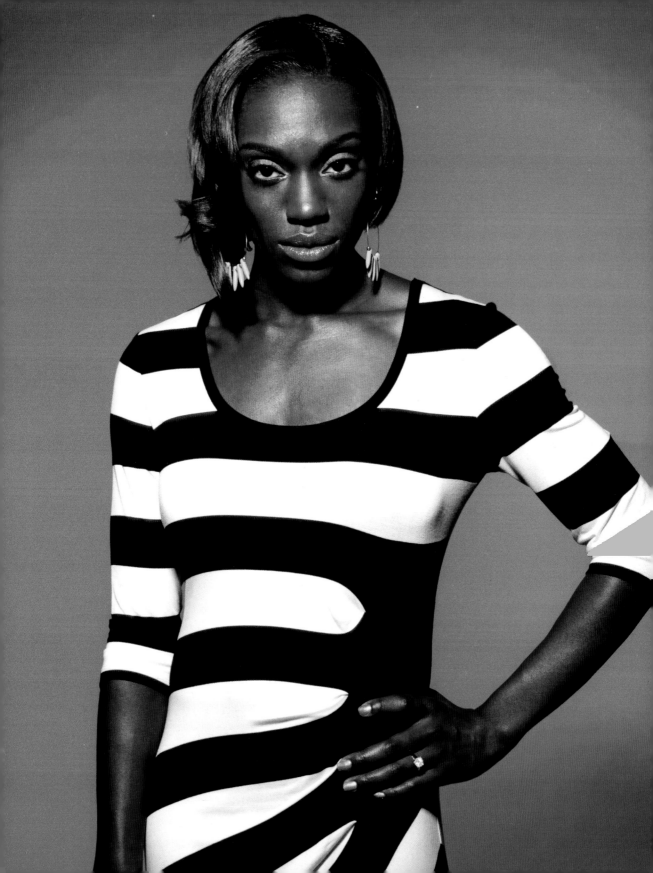

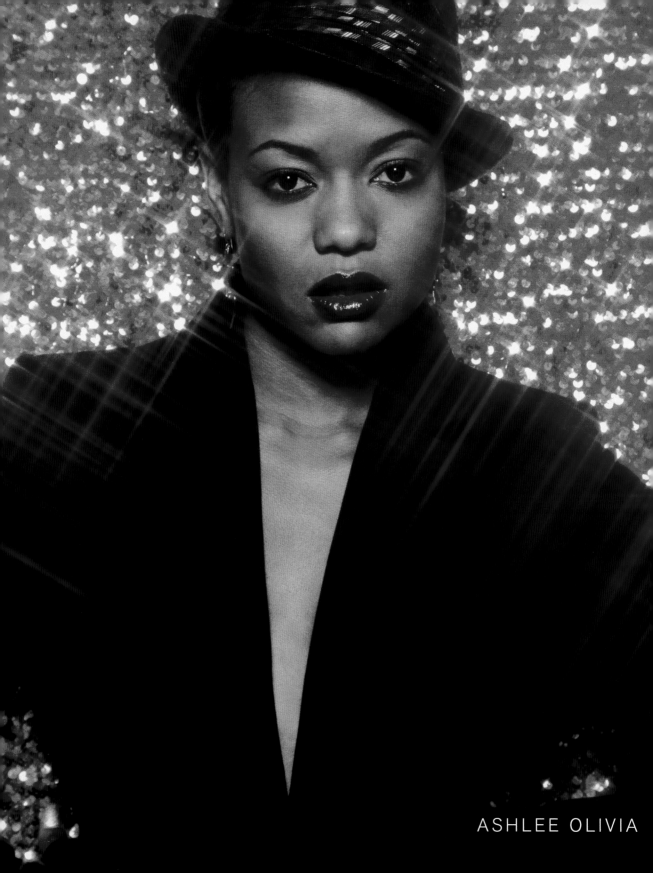

ASHLEE OLIVIA

"Black, like the color of the night; glistening in the morning's sunlight is the color of my beautiful dark skin."

—DONZALEIGH ABERNATHY

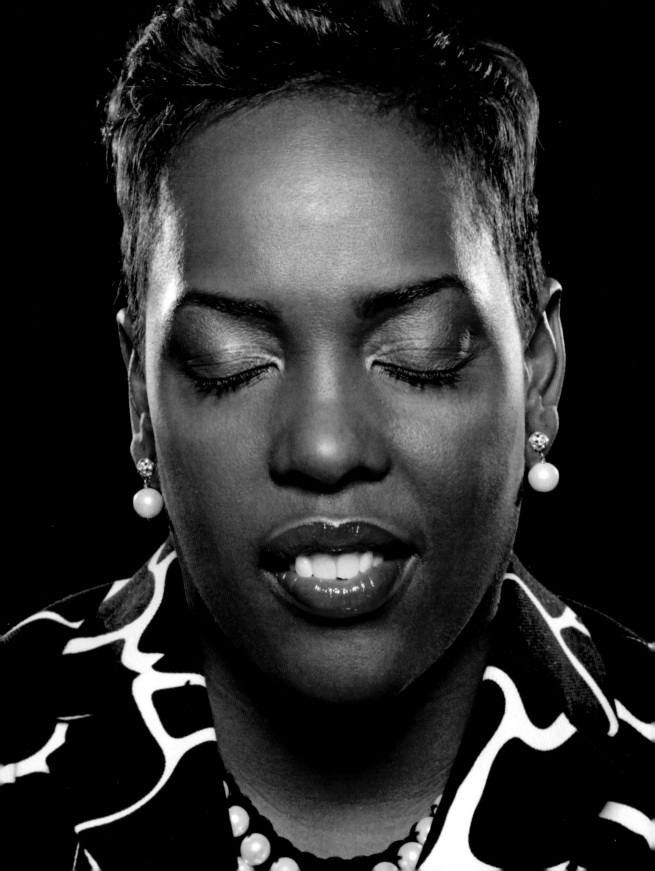

LUCRETIA CLEMONS JONES

ATTORNEY-AT-LAW

Back in my native town of St. Louis, Missouri, my maternal grandmother gave birth to twelve children. Most of them have very light skin and what people consider straight hair. I am the oldest of twenty-six grandchildren and like my father and his family, I came into this world with dark skin. My mother, who is one of my grandmother's lighter children, and my father both showered me with love and affection, which sustains me to this day. My mother's siblings and her parents treated me like a little princess and assured me that I would grow up to be a queen. They told me that I was bright and beautiful.

After the children at school brought it to my attention that I was dark, my family continued to make me feel like a pretty little girl. Forty years later those same great women made me feel like a pretty woman. They provided me with an unshakeable belief in my talents and my beauty. I am such a proud dark girl. My skin color did not make me who I am, those women did.

JADA HOLCOMB

My daughter, Zuri, is a beautiful dark girl. She is kind and caring. She is also autistic. I have not had time to be concerned about the color of her skin. What I care about is how my daughter will be able to survive on her own.

All the people who have frowned on dark girls do not understand real challenges. Every day of my life I worry about what would happen to my dark girl if I were not around.

It is my opinion that many children of color are not diagnosed early enough because less is expected of them. Let me tell you, I expect the world from my dark girl.

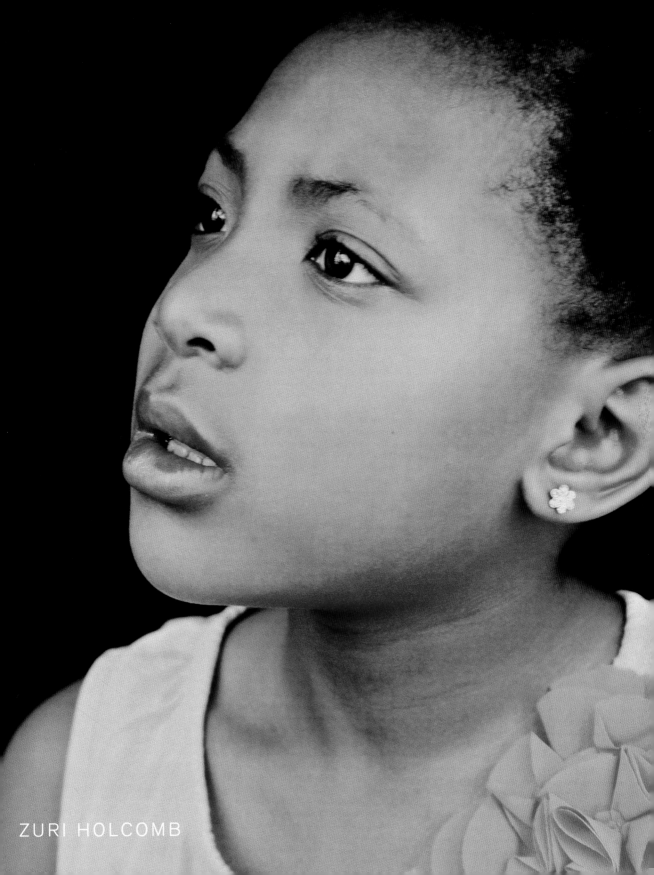

ZURI HOLCOMB

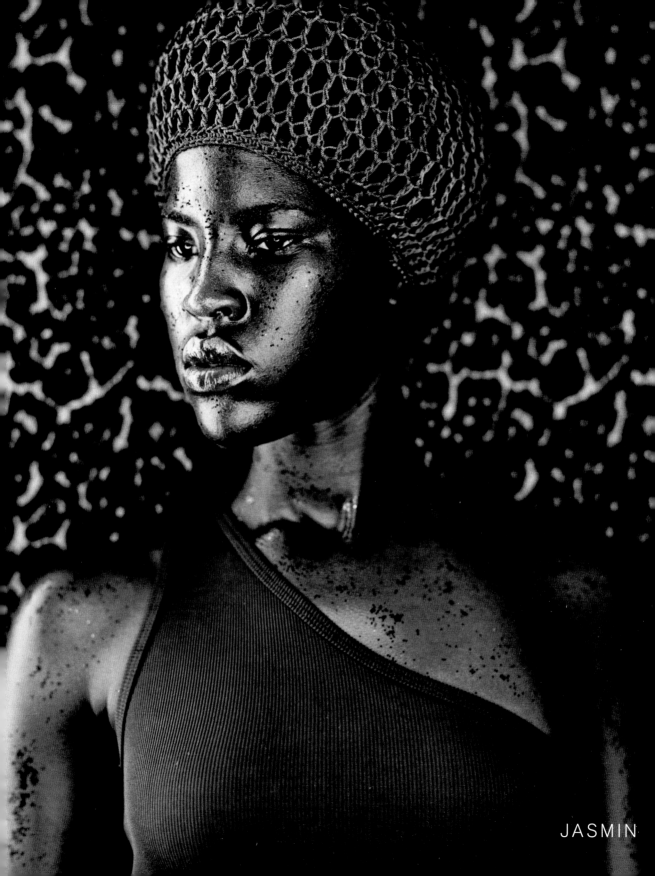

JASMIN

GRACE OCTAVIA

AUTHOR

I was riding with my cousin and his friends when they spotted some dark girls walking down the street. One of the boys said, "Look at the doo-doo girls." That was the nickname for dark-skinned girls and I knew it.

His comment got all the boys in the car laughing and talking about how dark and ugly the girls were. I felt so hurt because I was dark, and one day I would be walking down the street and a man would feel that way about me.

I really do not care what they say. I do not care if they shout or not. What I do care about is that I am a wonderful and beautiful dark girl who shares my life with others. As an instructor at Spelman College, I honor my students whether they are in sweats or designer clothes. They come to my class prepared and their eyes say, "We are dark girls and we are smart."

JENNIFER AUSTIN

STYLIST

My mother was born with caramel skin and beautiful hair. Her dark mother made a conscious effort to ensure her children were not dark skinned. A product of her time, my grandmother made sure her children had a light father. She told my mother that she was not happy when my mother married a dark man. "I do not want coon grandchildren," she said.

I am sad for my grandmother because she did not know how beautiful dark girls are. How beautiful we will always be.

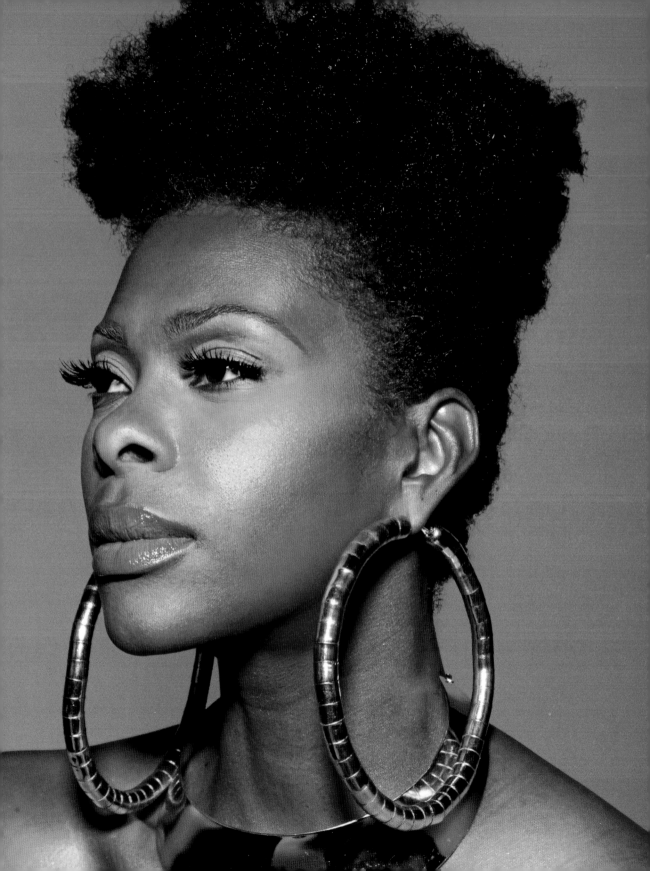

KIMBERLY KIMBLE

HAIR STYLIST

My darkness exudes strength.

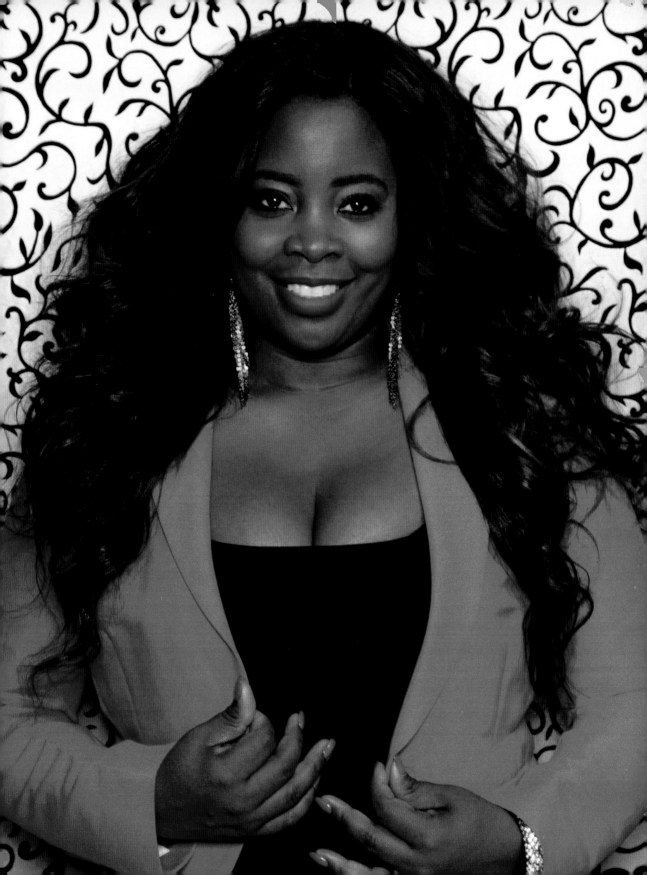

BRANDI HARVEY

COFOUNDER OF YOUNG, FIT & FLY FOUNDATION

Every day I mentor young women with my twin sister, Karli. I often ask myself, How long will we have this conversation about the color of our skin? It is my charge from God to inspire young women just like my mother inspired me, by affirming that I am smart and beautiful.

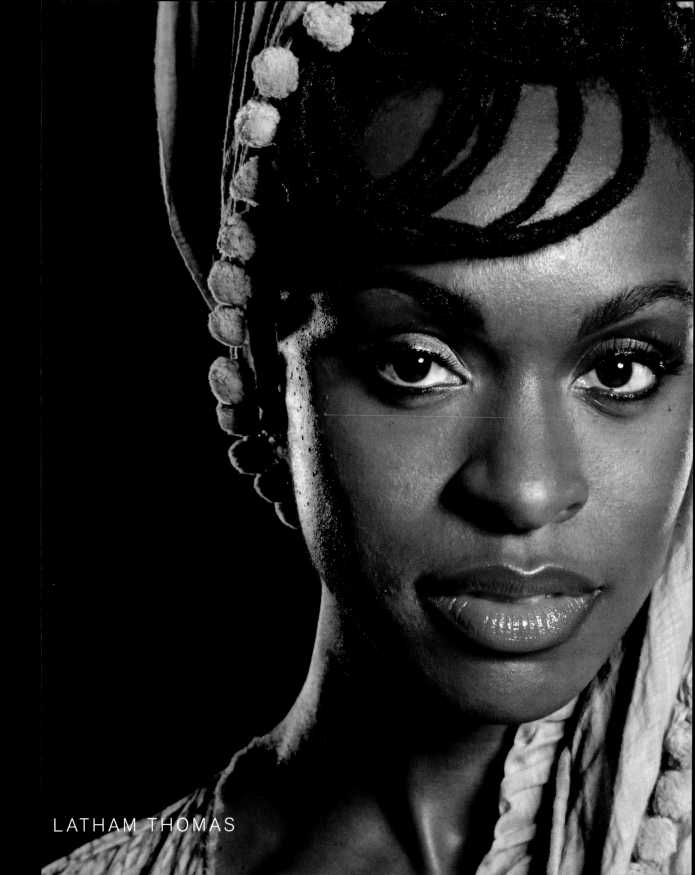

LATHAM THOMAS

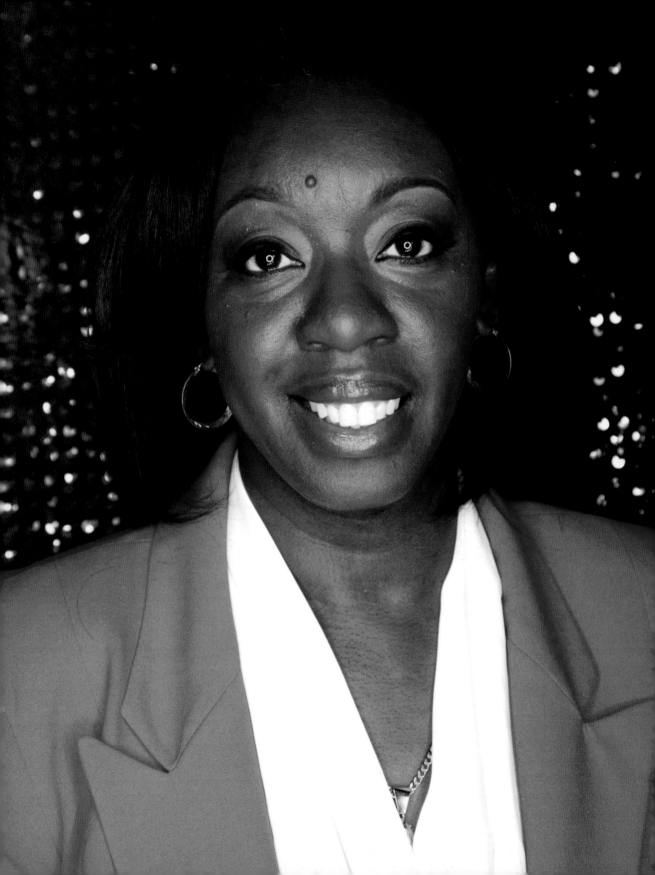

PAM WHITE

NEW YORK POLICE OFFICER

My father gave me the freedom to feel beautiful. I can still hear him saying, "My baby is the prettiest girl in the building."

I dated men who have actually said, "You are the darkest woman I have ever dated," like it was a bad thing. There is nothing bad about my dark skin. I embrace Pam. I embrace my darkness.

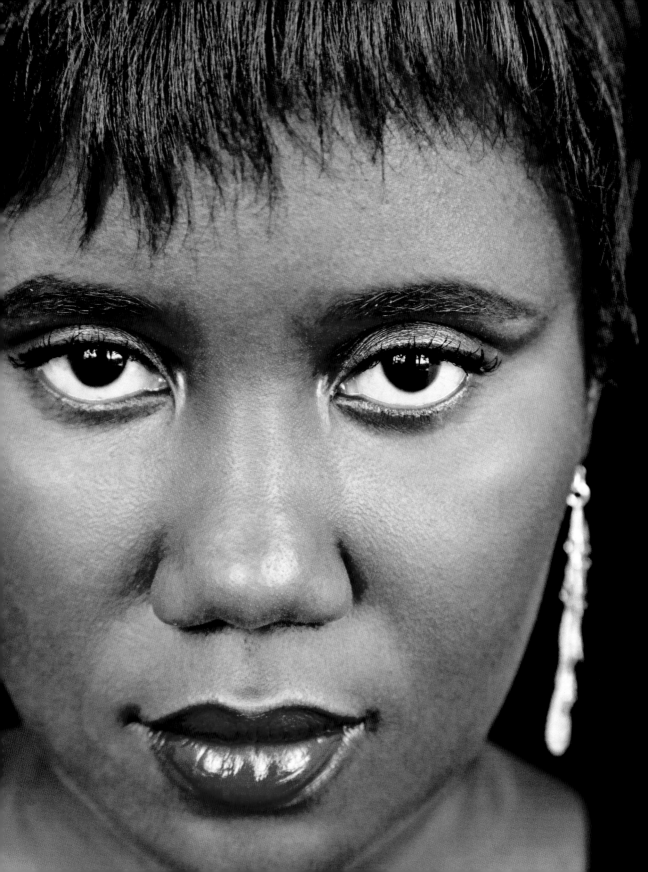

SHAMONDA STROTHER

REGISTERED NURSE

As a dark girl, I am proud that my house is filled with different shades of black-
ness. We are a family.

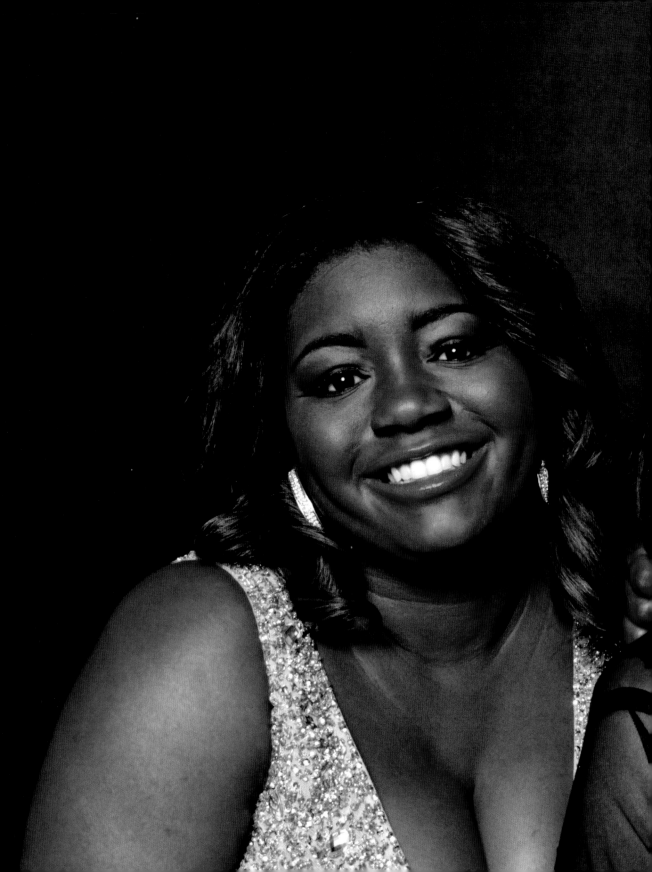

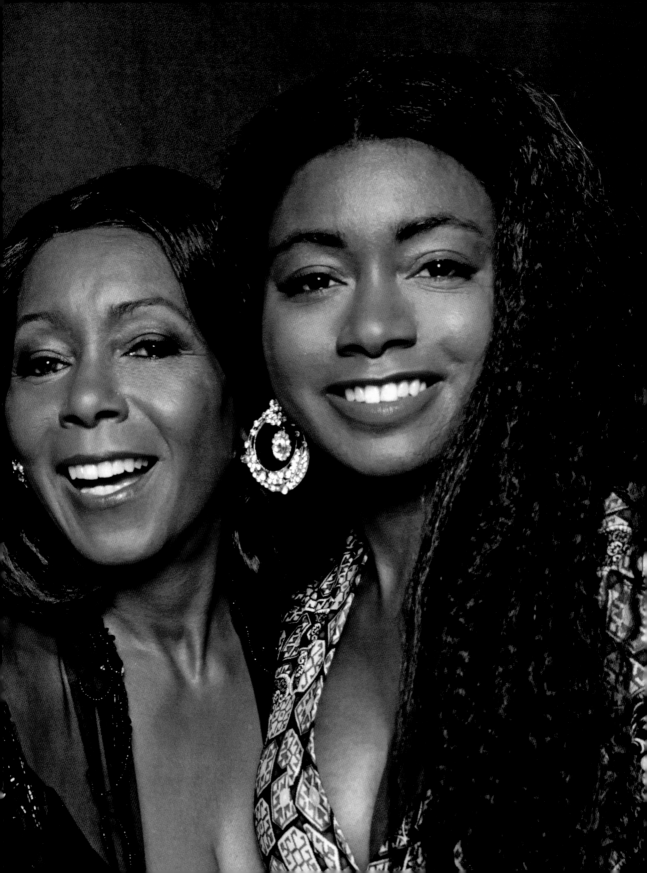

JUDY PACE

ACTRESS

"Judy Pace, most beautiful woman in Hollywood." —*Daily Variety*, 1962

JULIA MITCHELL

ACTRESS

I loved my role on *The Young and the Restless,* because Sofia is a dark girl with brains and beauty. The producers let me show what dark girls can really do. It is important to know what you can do without having to ask someone.

It is also important when you are in a relationship to know your value. When my now husband asked me to marry him, I knew he loved me because he was court-ing me hard all the way from Ohio.

SHAWN MITCHELL

LAWYER

Being a dark girl has never bothered me, but I have noticed and have had moments when I questioned why people think they can come into my life uninvited. With a wonderful dark girl mother and sister, I grew up with joy in my heart and head about who and what I am. I understood my goals and my purpose even as a child.

As a lawyer and a happily engaged woman, I still witness people coming in uninvited. My fiancé is very light skinned, and we often laugh at how people don't treat him the way they treat me. Moments as simple as me rushing in a deli once to order a sandwich.

"We are closed," the clerk said.

I went back to the car and played the race card with my soon-to-be husband.

"Go and get us a sandwich," I told him.

He came back with the food and we had a good lunch. What is there to say?— I am still a beautiful dark girl.

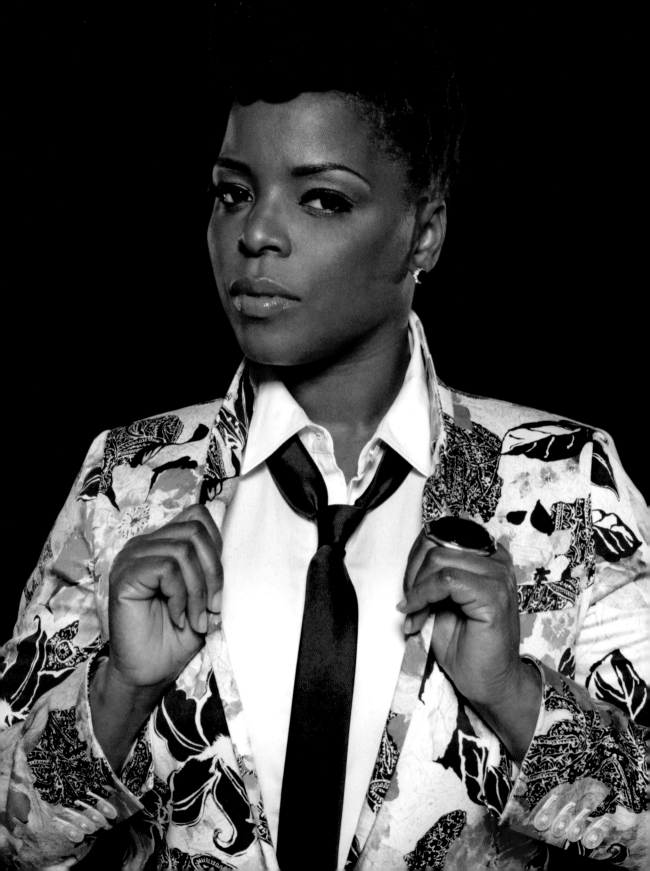

MOSHAY LAREN

**RADIO PERSONALITY, TV HOST,
AND DOMESTIC ABUSE ADVOCATE**

I started the Love Yourself Campaign, which is designed to spread the importance of what it means to love yourself. This work by far is one of the most gratifying gifts I have ever been given. Not only have I found the road to my own healing, but I can stop and pick others up along the way.

"If power is the ability to have your say over your life, then be determined to speak volumes. This is your fascinating journey—define it, own it, without limitations!"

—MIKKI TAYLOR

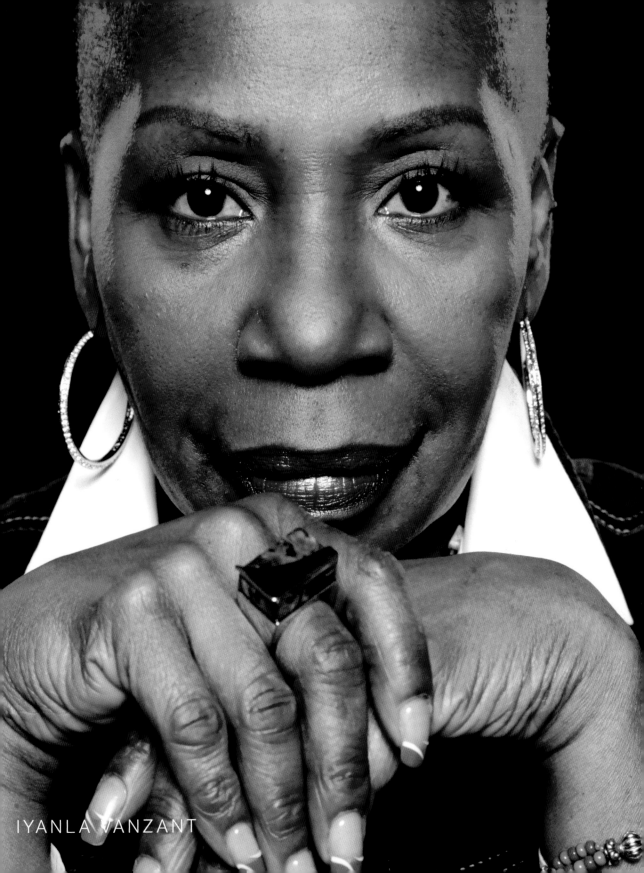

IYANLA VANZANT

FLOYDETTA MCAFEE

COMMUNICATIONS STRATEGIST

I know and understand my history as an African American. I come from the blood-line of many proud and self-assured people who are dark like me. I embrace that bloodline and our skin tone. In this dark skin I was born, grew up, traveled the world, and live proudly.

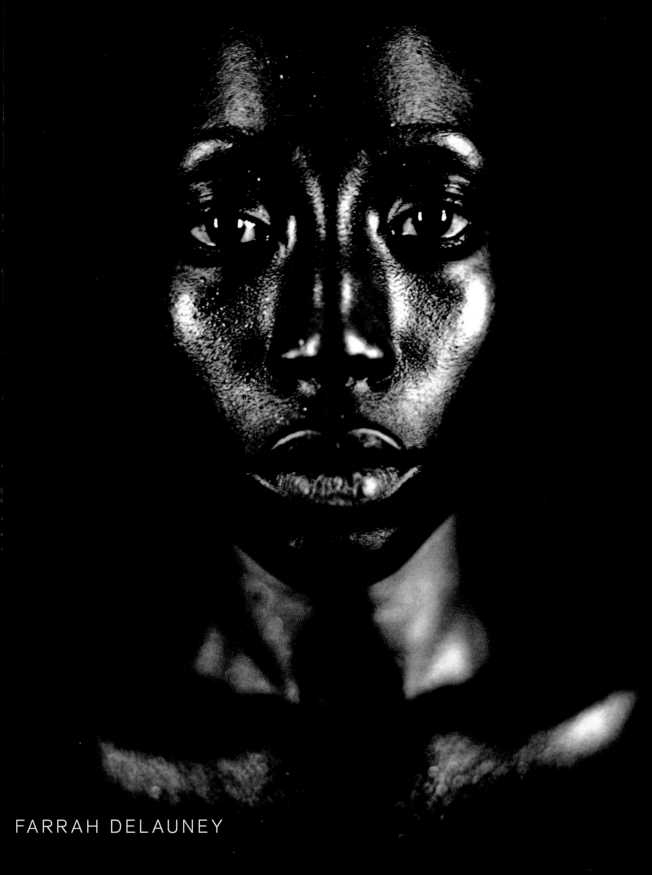

FARRAH DELAUNEY

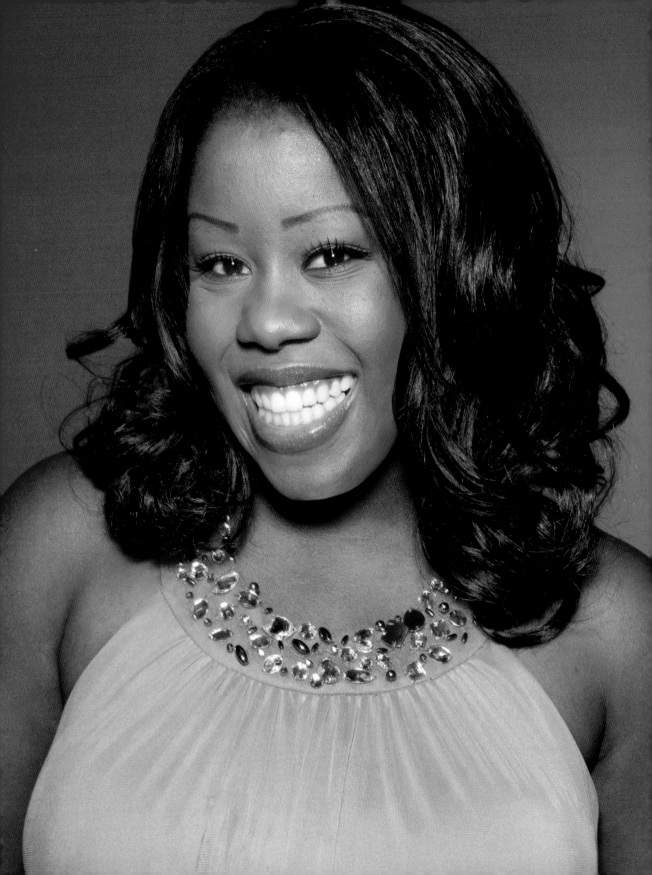

VANESSA ROBERTSON

OFFICE MANAGER

Dark girl, be your own biggest fan. If you think you are the greatest, everyone else will, too.

NALO CAMARA HAMPTON

**EXECUTIVE DIRECTOR OF EDUCATION,
SHARE LOVE FOUNDATION**

Never allow anyone to take your power.

My mother, father, and uncle were the first to tell me that I was beautiful. When I was a little girl, they encouraged me to aspire to be a model. Even though I never saw dark-skinned girls on the covers of magazines, I still had that dream. In high school, "Grace Jones" was my nickname, as an insult because of my dark skin. It didn't matter because I thought she was the most beautiful woman in the world. I loved everything about her.

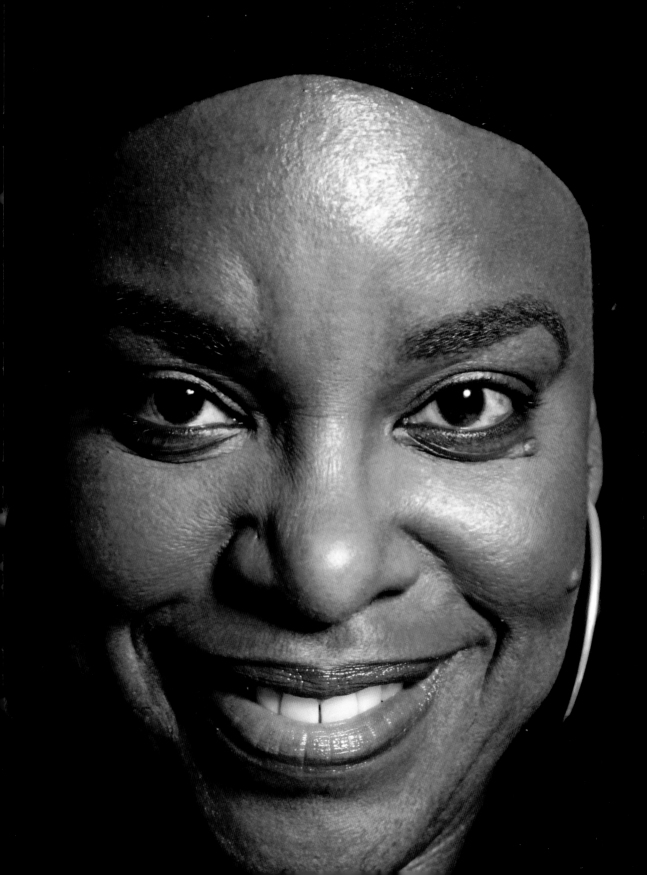

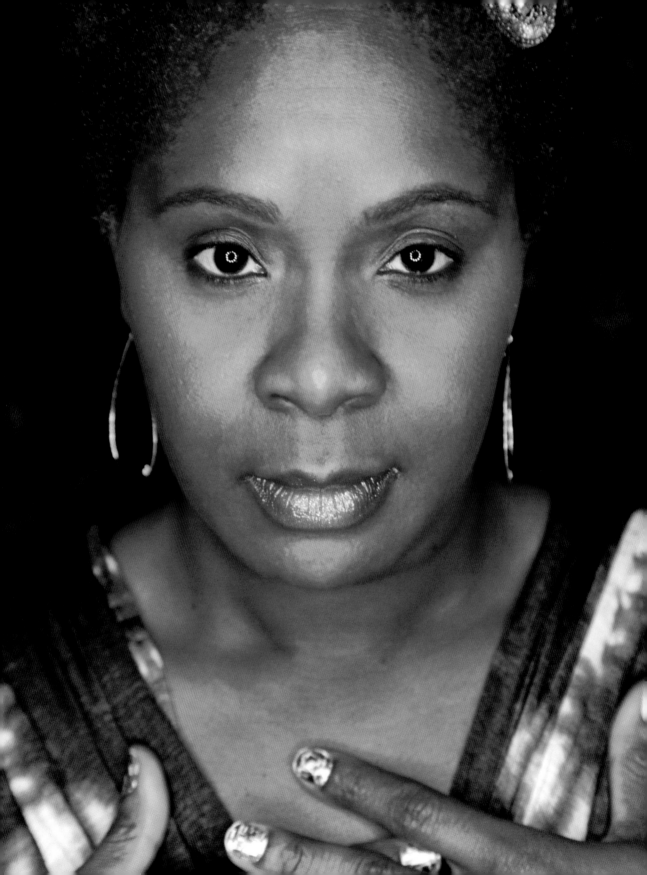

ROBYN GREENE ARRINGTON

TELEVISION EXECUTIVE

I love that my spirit is colorless and yet all the colors of the spectrum at the same time. I love that my spirit is encased in my brown skin. I love that my brown skin tells the story of survival from the shores of Africa . . . through the Middle Passage across the turbulent Atlantic Ocean . . . then the brutal South . . . and the challenging north of the United States . . . and now to destinations my ancestors could never have imagined for their descendants. I love my brown skin.

I do not take my role as a black woman in real life or behind the scenes lightly. I am extremely conscious that my personal image and the images I produce have a direct impact on the world at large. As a producer, I belong to a select, privileged group of decision makers who generate content with far-reaching effects on how individuals view and treat themselves and others. I realized very early in my career, in order for me to effectively communicate universal human stories that capture the attention and hearts of viewers, one must create from an authentic, vulnerable place rooted in love, the love of one's self, which automatically yields love to others. It is through love that we connect and learn to respect. We also transcend labels while embracing our individuality. Being a dark girl, prepared— actually fortified—me for my ongoing journey as a citizen of the universe paying forward lessons learned by all means available.

"In this dark skin lies the root, the story of all of humanity. In denying it, you deny yourself."

—PERES OWINO

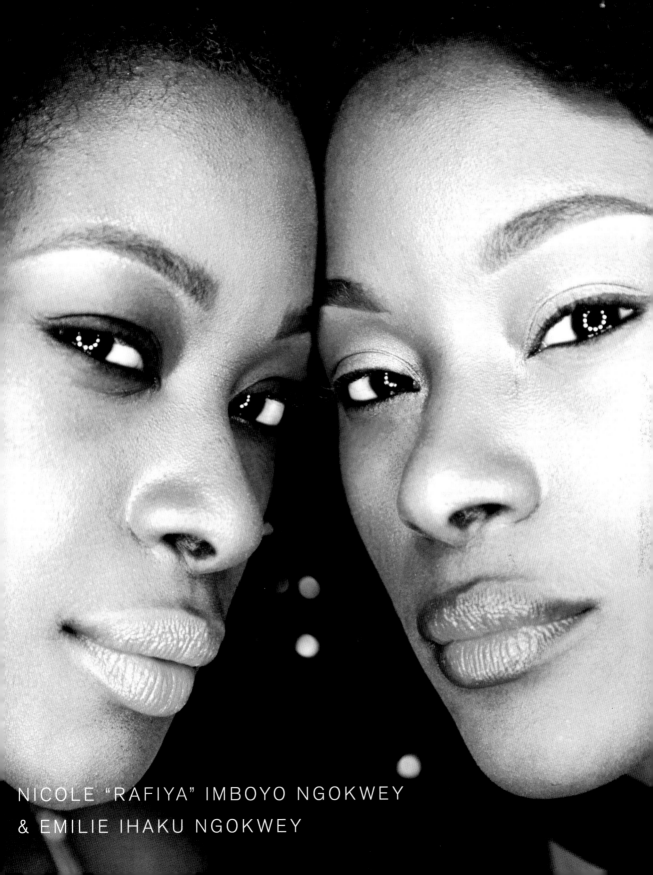

NICOLE "RAFIYA" IMBOYO NGOKWEY
& EMILIE IHAKU NGOKWEY

GINGI ROCHELLE

TV AND FILM PRODUCER

"You'd better be smart, girl, because men don't like dark women," said my aunt.

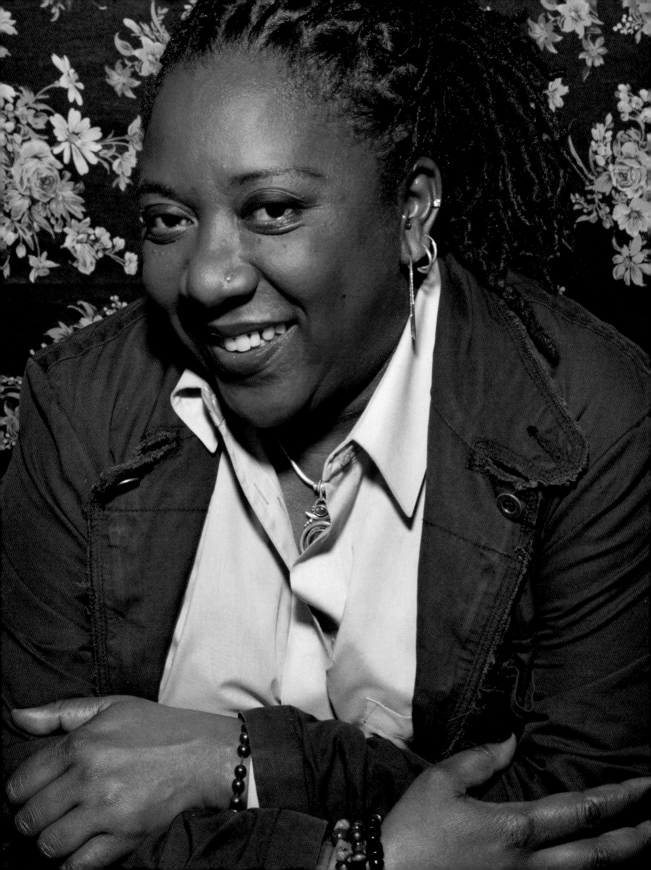

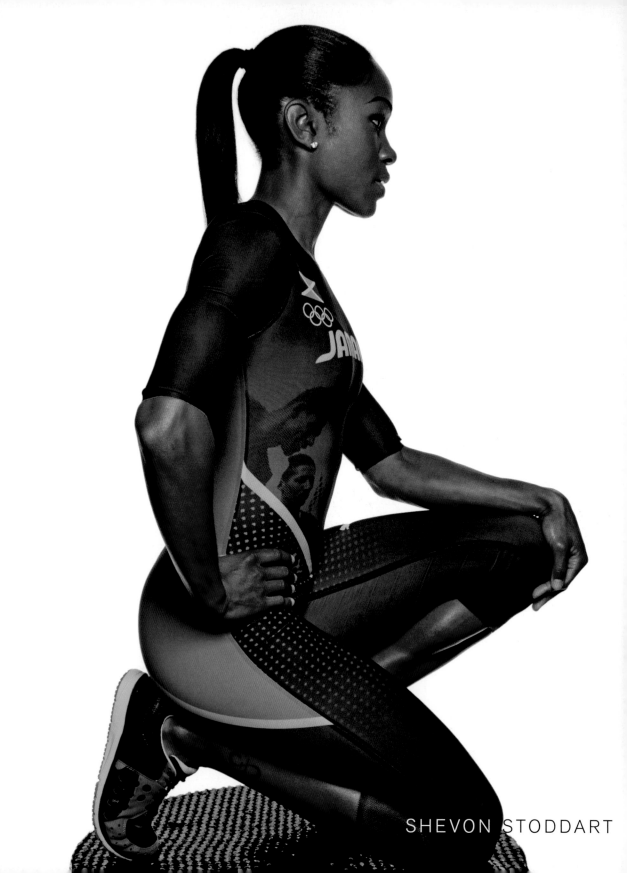

SHEVON STODDART

KARLI HARVEY

COFOUNDER OF YOUNG, FIT & FLY FOUNDATION

Dark girls . . . all girls . . . you'd be a sad dog if you couldn't wag your own tail.

JOI DUKES

I am a nineteen-year-old dark girl. I learned very early in life that the way people felt about my dark skin was their issue, not mine.

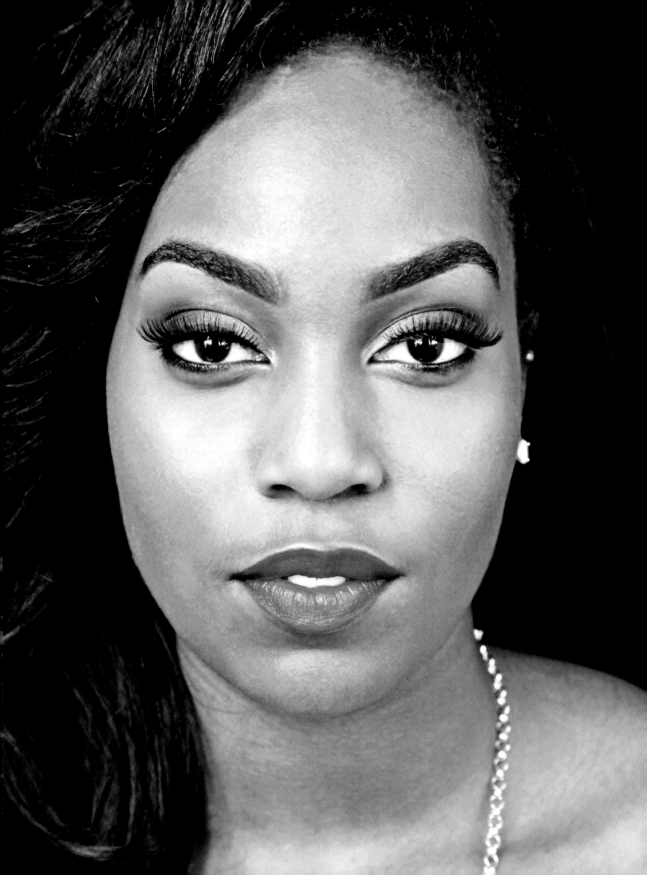

SANDY WASHINGTON

BUSINESS OWNER

"Pretty is as pretty does." That was the saying in my house as I grew up. Beauty was not something you were praised on. My maternal grandmother always said that the way you looked had nothing to do with you, but instead your parents. However, the kind of person you turn out to be has everything to do with you. Your choices and how you apply yourself is all you. So in my house, beauty was something that was never discussed.

Sometimes I think that growing up and not being praised for my beauty did me a favor. It made me focus on character. As an adult, I have a strong sense of both.

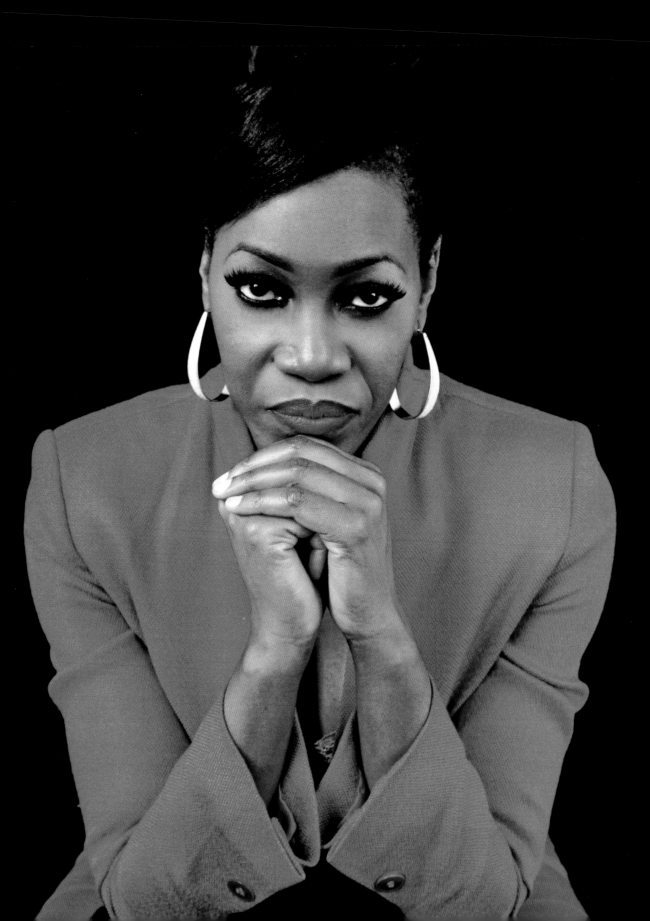

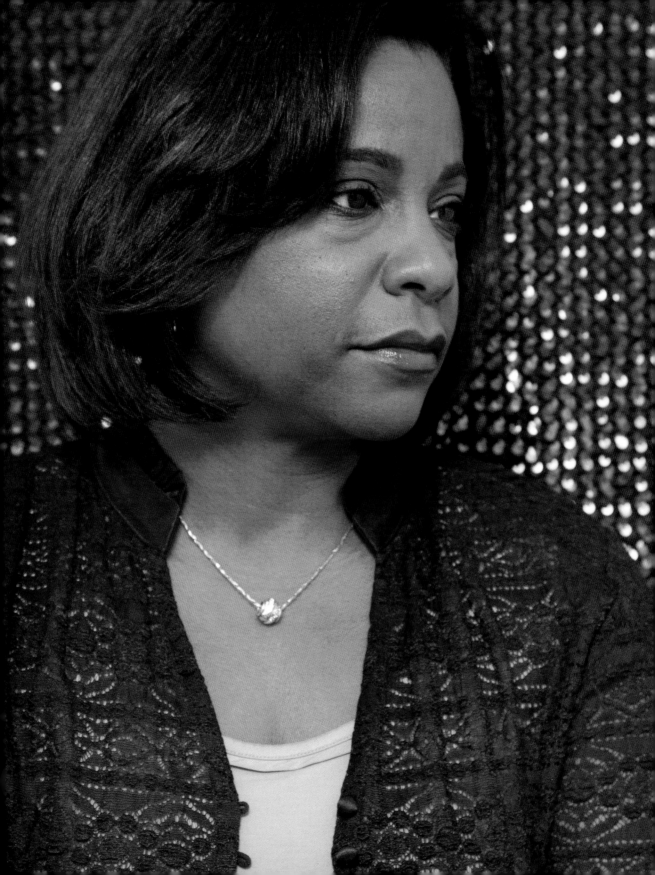

TONI GASKINS

SCHOOL GUIDANCE COUNSELOR

Who you are, and not the hue you are, determines your destiny.

My mother died when I was eleven years old, so my sister, Debbie, and I were raised by our grandparents. We were raised with love, faith in God, and devotion. I can't really remember my grandparents saying, "Toni, you are beautiful." They did not need to say the words, nor did I feel the need to hear them. I received what I needed, and that was being treated like I was beautiful. As a matter of fact, they treated us like we were two princesses. Only a person's character mattered in our home.

When we walked out the door, we felt safe and secure with who we were as young women. Two sisters, one light skinned and one dark skinned, bonded together by love.

At the school in the Bronx where I'm a guidance counselor, there's a diverse collection of African Americans, Africans, Islanders, and Hispanics along with a small population of white teachers. The students are very confident and generally accepting of one another. I think it speaks to how society could be. There are pockets around the United States where color is not an issue. The rest of America could learn a lesson from my students.

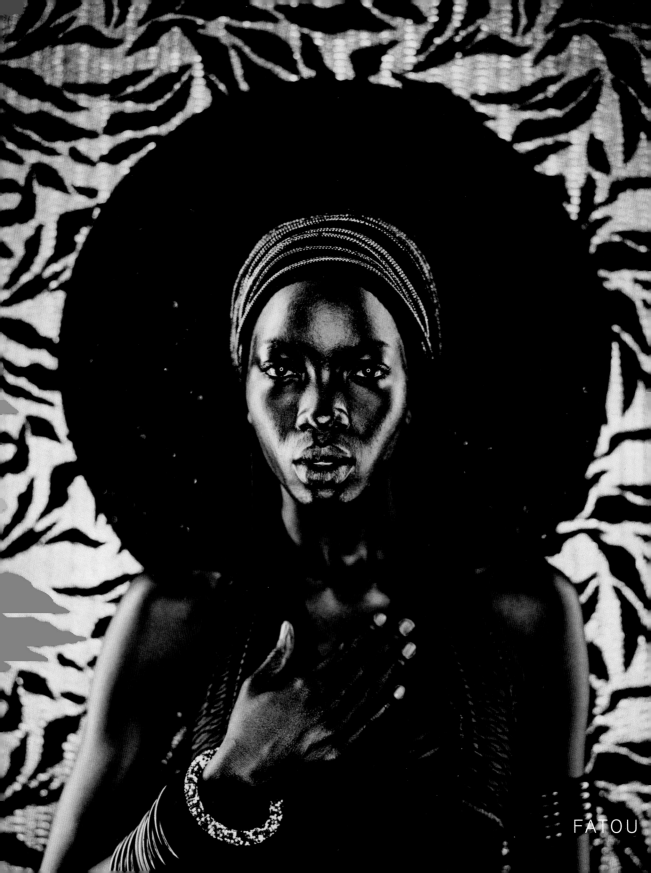

FATOU

"My skin color is not a reflection of who or what I am. Instead, the brilliantly implemented undertones are an indication of God's will for diversity, acceptance, and admiration of something rare. Unconventional, revolutionary beauty is to be appreciated." —JOI DUKES

ELAYNE FLUKER

FOUNDER AND CEO OF CHICREBELLION.TV

I grew up with people who loved me unconditionally. They did not judge me by the color of my skin. When you leave the comfort of your home, the world changes. One experience I will never forget is being on the track team. We were at the starting line when my white classmate looked at me and said, "You are only fast because your people were slaves." That hurt, but she was right about me being fast. I beat the pants off that girl. I have been running ever since. Running to succeed and make a difference in the lives of others, not outrunning my darkness.

In the media I have the opportunity to be a voice for young dark girls. I tell them to run their own race. I am a very proud dark girl.

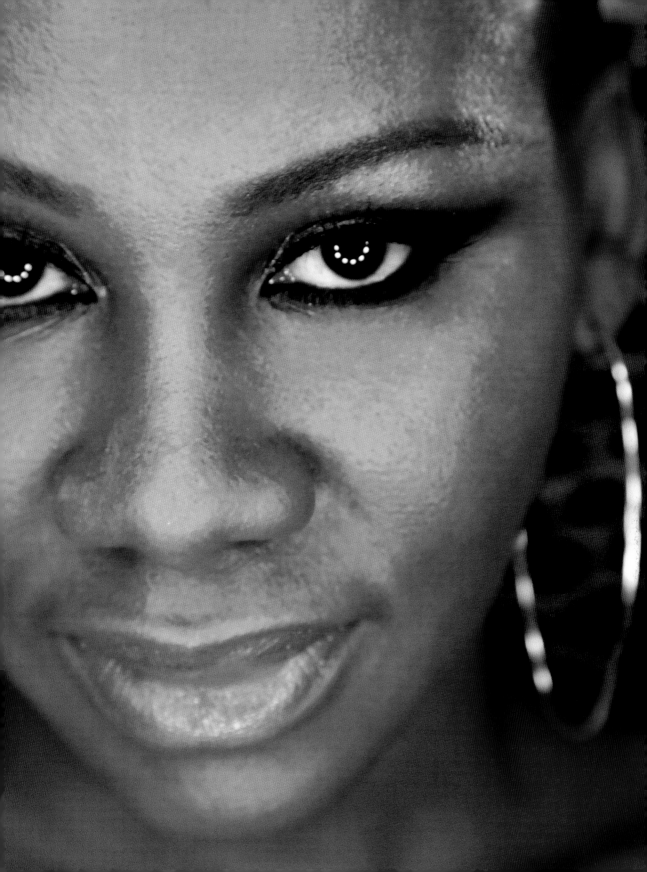

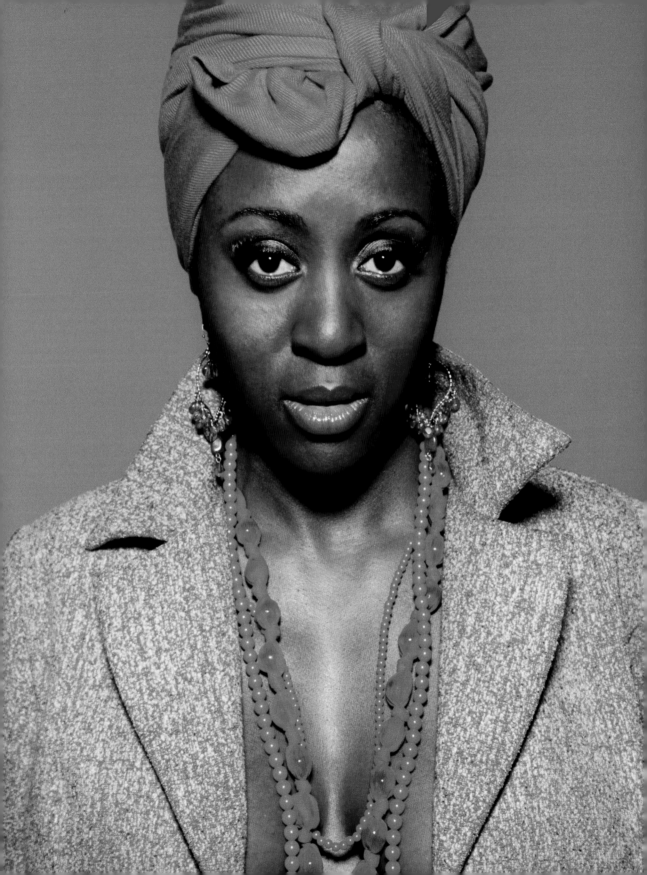

PERES OWINO

ACTRESS, WRITER, AND PRODUCER

I came from Africa to America ten years ago. Once I arrived I was immediately put into the class of a dark-skinned woman. A woman who black men barely noticed. When they did look at me their eyes said, "I don't want an African woman." That translated to "I don't want a dark girl." As a matter of fact, I can count on one hand the black men who have been attracted to me. On the other hand, there were countless white men who found me to be beautiful, one so much so that he became my husband.

Being married to a white man brought about a challenge from people of my own color. Men who previously denied me their attention were trying to judge me. I remember one brother calling me a sellout.

I responded with, "When this man and I have a child, she will be the type of woman black men like you really want to date. So in that respect I am looking out for you, brother."

DONZALEIGH ABERNATHY

ACTRESS AND DAUGHTER OF
CIVIL RIGHTS ACTIVIST RALPH ABERNATHY

I am a child of the civil rights movement and the daughter of a Southern Baptist preacher. I remember when church women were visiting our home and I overheard them talking about me and my sister. They were comparing our skin tones and favoring my sister's because hers was lighter. I do not remember feeling sad. I remember knowing that what they were saying was wrong.

As children of the movement, my siblings and I, along with Yolanda King, were the first black children to attend Spring Street Elementary School in Atlanta, Georgia. We were called n— from the moment we walked through the door until the moment we left. It was painful enough for my own race to show favor to my sister because of skin color, but true racism toward an innocent child at the hands of white teachers and students was a new ball game.

They didn't care that Yolanda and my sister were light skinned. We were all n— to them. I fought for justice like my dad did, only he preached nonviolence. I, on the other hand, was physically fighting whenever I needed to. If a white kid said one word to us, I forgot all the teaching I overheard in my living room and went to war.

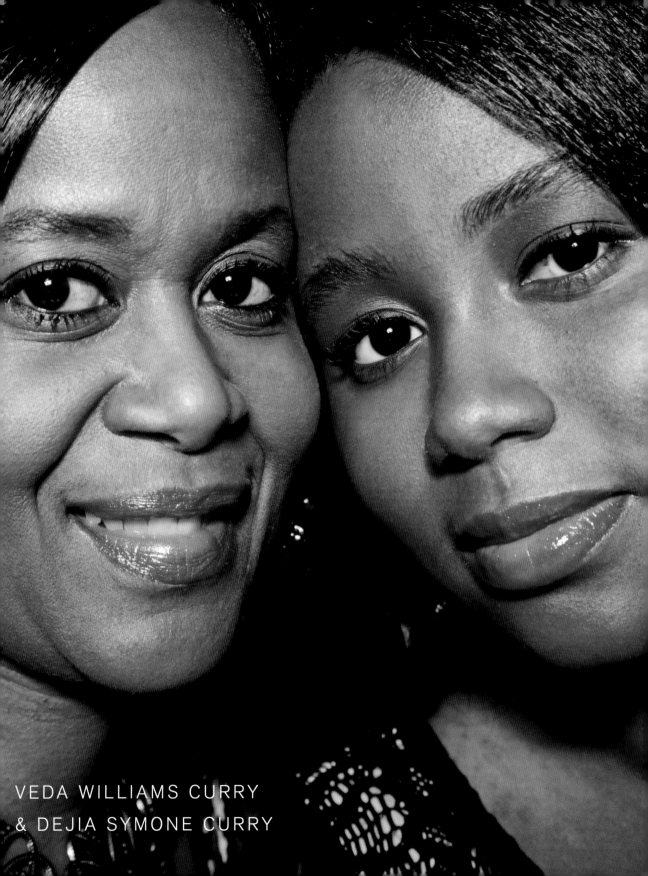

VEDA WILLIAMS CURRY
& DEJIA SYMONE CURRY

SHERYL UNDERWOOD

ACTRESS AND COMEDIAN

I was a daddy's girl, to say the least. I know for sure that my father loved me. He assured me every day that I was beautiful, smart, and special. My dad had a brother named Uncle Waddell, and he was big and black with coal-dark hair. He reminded me of a black Jackie Gleason. He was so proud and fly that he made me proud of my dark skin. With the love of these men tucked in my heart, I was always comfortable in my skin.

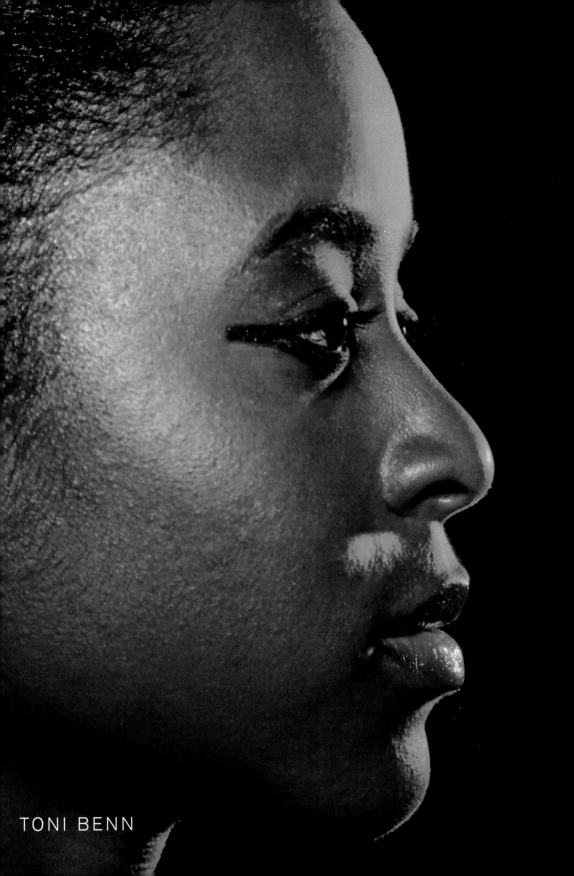

TONI BENN

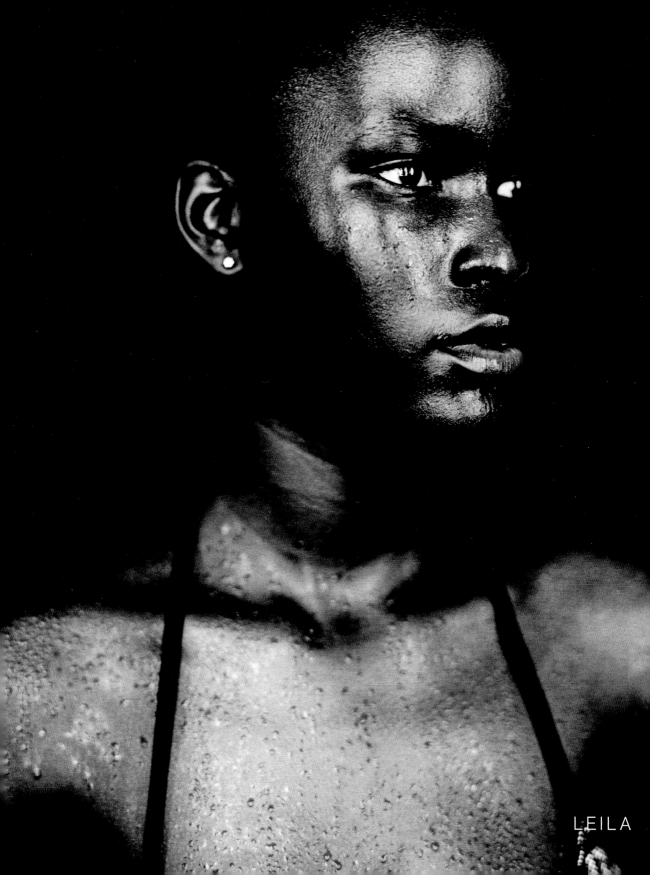

LEILA

RACHAEL MCLAREN
HOPE BOYKIN
JUDITH JAMISON

ALVIN AILEY DANCERS

RACHAEL MCLAREN

I am convinced that race matters, but so does hard work and character.

HOPE BOYKIN

I was walking down the street in New York when a brother stopped in his tracks and said loudly, "If I had known black could be so beautiful I would have never married my wife."

No offense to his wife, he just saw how beautiful black could be.

JUDITH JAMISON

My father was dark, dark, dark. My mother was also dark. They gave birth to this dark girl who grew up to be dark and tall. I knew I was put here with greatness and I went after that greatness with force. Excellence makes my skin color secondary.

IMPACT OF COLORISM ON SOCIETY

DR. TENIKA JACKSON

Although Alice Walker coined the term "Colorism" in 1982, its origins date back to the days of slavery. It refers to discrimination based on one's skin tone. Certain privileges were afforded to individuals who possessed lighter skin. For example, slaves who had dark complexions typically worked in the fields picking cotton while their fairer-skinned counterparts worked inside the house. In some instances, African American slaves were able to "pass" for white and avoid some discrimination because their skin was so light. In the twentieth century, African American sororities and fraternities used the "paper bag test" as part of their admission requirements: If you were not lighter than a paper bag, you were not good enough to associate with them. Spike Lee satirized this point in his 1988 film, *School Daze*. In other countries, such as Asia, Latin America, and India, light skin was linked to higher

class status. If you were a member of the bourgeoisie, you did not have to work outside in the sun and you were deemed more desirable. It was not long before light skin and privilege were somewhat synonymous in the United States.

In today's society, dark skin has been linked to longer prison time, higher unemployment rates, low self-esteem, lower standards of beauty, and higher psychological distress. The skin bleaching industry is a multi-million-dollar business. Women go to great lengths to lighten their skin in an attempt to be more attractive in the eyes of male partners and society as a whole. Studies have also found that young girls have internalized Colorism

as well. They feel as if they are not as "pretty" or "desirable" as their friends with lighter skin. That is one of the reasons why this project is so important. It is showcasing dark girls from all over the world. We are sharing our stories and explaining how we have coped with Colorism over the years. This book will be an inspiration to many people. Instead of young girls singing the old children's rhyme "If you're black, stay back / If you're brown, stick around / If you're yellow, you're mellow / If you're white, you're right," they will chant "The blacker the berry, the sweeter the juice." People will realize that our dark skin tone makes us unique and beautiful as opposed to viewing it as a constraint that needs to be altered or avoided.

ACKNOWLEDGMENTS

Dark Girls could not have happened without Jeff Silberman, our dedicated literary agent. I am eternally grateful for the vision, hard work, and foresight of Tracy Sherrod. I'd also like to thank Kathleen Baumer and the entire staff at HarperCollins for their support. In addition, I want to recognize the long hours and diligent efforts of Shelia P. Moses, who suggested this book's creation based upon her viewing of my *Dark Girls* film. I'd like to express my gratitude to our photographer, the great Barron Claiborne, and his staff for executing this vision.

Furthermore, I must acknowledge the strength and wisdom of my mother, Ethel Duke; and the strength of my sister, Yvonne Duke Hampton; and my niece, Nalo Hampton. They inspired the *Dark Girls* film.

Next, I'd like to especially acknowledge my Duke Media staff: John P. Rigores (producer) and Chiijmree Williams (production coordinator), who organized and coordinated all the photo shoots. I'd also like to acknowledge the talent and casting coordinators, Joyce Coleman and K-Tusha Croom, who booked and organized all the beautifully talented women.

With much appreciation, a special thank-you is owed to Nelson Pena for managing the New York Unit and Gina Barboza for managing the Atlanta Unit, as well as our hard-working and motivated production staffs in Los Angeles, New York, and Atlanta.

The ultimate acknowledgment belongs to each and every woman in this book, for having the courage to share her story and offer her image in spite of all the challenges life has presented and continues to present, just because of the color of her skin.

This battle is not over. Despite the many battle scars they bare, from the wounds

globally and also sometimes as a self-imposed resistance to healing, as the great poet once stated, "Still they rise." I simply want also to acknowledge all of our blood, sweat, and tears that have come together to create *Dark Girls*, a book of the past, present, and future recognition of black women's beauty and self-worth. Rise. Dark girls, rise. Rise. Dark girls, rise. Rise. Dark girls, rise.

SPECIAL THANKS

Simone Moore (Camera Assistant)

Juanita Diaz (Makeup Artist)

Elyse Mclinton (Production Assistant)

Erin Dennison (Production Assistant)

Erik Douglas (Production Assistant)

Brandon Steele (Behind the Scenes)

Tim Alexander (Location)

Onyxx Monopoly

The Yellow Tomato Catering

Impeccable Taste Catering

Richard H. Rose (Camera Assistant)

Nelson Pena (Production Coordinator)

Joseph Esbenshade (Production Assistant)

2Stops Brighter Studios (Location)

Philip Stark

Pamela Barrios (Makeup Artist)

Derrick Keith (Hair Stylist)

Gina Barboza (Field Producer)

Codex Collective Studios (Location)